■ Contents

■ Introduction

The Earth From Space

Everybody knows that the Great Wall of China is the only object visible from space. Similarly, there can't be anybody who doesn't know that the wall is also the only man-made object discernible with the naked eye from the surface of our Moon.

This is of course, complete nonsense. No matter what you believe or what you've been told, this book intends to prove beyond a shadow of a doubt that this often quoted 'fact' actually couldn't be further from the truth.

The first time someone made this bold statement was in 1938. Yes that's right. 1938, which was 23 years before Soviet cosmonaut Yuri Gagarin became the first man to orbit our planet. So, once humans finally did achieve space travel, did any of those astronauts see the Great Wall? Well ... not exactly.

There is debate between the very few people have been lucky enough to experience Earth from hundreds of kilometres above, about whether or not the Great Wall is indeed visible. Some claim to have seen it from low orbit, whilst others adamantly protest that the wall is so similarly coloured to the surrounding landscape that there's just not enough contrast to pick it out. This suggests that the structure's visibility is highly dependent on light and atmospheric conditions, and proves that from the Moon (which is over a thousand times further away) there would be no chance at all of picking it out.

However, in 2005 Leroy Chiao, a Chinese-American astronaut on the International Space Station, did manage to take a photograph of the Great Wall of China. The Chinese Government (who naturally have a vested interest) claim that this proves the wall is visible to the naked eye, as the camera used was a commercially available model. Of course they failed to mention that when the shutter actually opened, Mr Chiao wasn't even sure he was pointing the camera in the right direction.

So the Great Wall of China isn't really visible from space with the naked eye, but does seem to be recognizable provided you know some basic Chinese geography, and have a large enough zoom lens on your commercially available camera. Hang on though ... what about non-commercially available cameras?

Technology

As technology has improved and globalization has marched ever onwards, more and more satellites have been launched into orbit around our world. Today satellites form a crucial part of the global network which we depend upon for so much of modern life.

We rely on satellites for hundreds of kinds of services in the modern world – from secret government communications to international phone calls, from intercontinental TV broadcasts to ham radio, from GPS systems which locate lost ships to the route-finding system in your car, from monitoring climate change to charting street maps – there's hardly an area of life which hasn't been affected by the unseen hunks of metal flying over our heads at 8km per second.

Of course one other task which we employ satellites for, is keeping track of our world from above – made possible by the highly advanced, extraordinarily expensive, and definitely not commercially available cameras which some have installed on board.

The majority of the images you will find in this book were taken by DigitalGlobe's dedicated photographic satellite, QuickBird. Launched in October 2001, the 950kg satellite is only 3m across and orbits the Earth at 450km in a 98-degree, sun-synchronous orbit.

A sun-synchronous orbit is a near-polar orbit with a specific altitude and inclination that means whenever the satellite passes over a specific point on the Earth's surface it is always the same local time. For example, the satellite might cross the equator 12 times in an Earth day and at each time it will be over a different part of the world, but always at 3pm.

This sun-chasing is perfect for photography satellites as it means they are in perpetual daylight and can therefore be capturing images of the world below continuously – QuickBird is capable of collecting 75 million sq km of imagery in just one year. As the Earth is not only rotating around itself but also orbiting the sun, the satellite must adjust by around one degree eastward each day. This way it will complete a full 360-degree adjustment in one year and always stay on the sunny side of the Earth.

As QuickBird has no pilot or crew, its life expectancy is limited by the amount of fuel it carries – and it was loaded with 7 years worth. That's 75 million sq km of imagery every year for

The Great Wall of China, as now viewable from satellite

7 years. Given that the images captured by QuickBird's camera will show up a red cushion placed on your back lawn, 525 million sq km of images is just a little more than anyone could ever hope to examine pixel by pixel.

No wonder then that's there's an endless supply of undiscovered mysteries waiting to be unravelled in all that imagery; but how would you find them?

The Power of the Internet

In April 2005, the Internet giant Google added another branch to their search engine empire when they launched their revolutionary online map service, Google Maps. The site featured stunning photos of large parts of the Americas taken using a combination of satellite and aerial photography, which featured an incredibly intuitive interface that encouraged people to explore. Suddenly there were high-quality, easily accessible, and totally free-to-view images of thousands of places across the United States and Canada ready to be examined pixel by pixel.

As web developers, the authors of this book were aware of Google Maps within minutes of launch, and we immediately began excitedly scanning the photos for recognizable landmarks.

After spending that evening tracking down more sights and sharing them with our friends, we decided to share our discoveries with a wider audience, and with little fanfare, Google Sightseeing was born.

We didn't expect the site to last more than a few weeks – in fact we probably thought we'd get bored, or more likely run out of interesting sights to share. However, as the visitors started pouring in they all brought their own suggestions of things that we might like to look at, and we soon realised that even though there was only satellite imagery for the Americas at the time, we already had enough things and places to keep us going for a while.

We also didn't expect so many people to be interested in the places we were sharing! Our small webhost soon had to ask us to relocate the site to somewhere which could better handle the demand. In June 2005 Google Maps was updated to feature imagery of much more of the globe, and soon afterwards Google released the first free version of Google Earth, a previously commercial product from a company called Keyhole, which offers a virtual globe for exploring the satellite images. With all these new images, new ways to explore them and new interest building all the time, we were completely hooked.

Google Sightseeing has continued to expand and grow, offering readers new and exciting places to visit each day from the comfort of their chair with Google Earth or Google Maps.

This book you are now holding is our attempt to cram a year's worth of posts into one small book, so we've picked our favourite weird and wonderful sights, researched them further, and acquired the very best satellite images available – including some which aren't even in Google Earth!

This is by no means a definitive list of any kind of things – it's really just a sampler of some of our favourites (for whatever reason) from our first year of sightseeing. We know for a fact that there's an endless supply of new and fascinating things to see, and we hope that you enjoy them as much as we have. We also hope they inspire you to load up Google Earth and go searching for the weird and wonderful things to see in your neighbourhood. Or in someone else's neighbourhood – there's a whole globe out there!

Just make sure to drop by www.googlesightseeing.com and let us know what you find.

■ The Richat Structure

When the first space missions left the surface of our planet, a series of vast, fantastic warts on the face of Africa were discovered. This one is known as the Richat Structure and is 50km across – so big it had been unrecognizable from ground level. Because of the structures' circular presentations, scientists initially believed that they were impact craters left by meteors crashing into Earth.

These days it is generally accepted that these massive scars are actually ancient geological features, which have been subjected to hundreds of millions of years' worth of erosion. The elements have acted upon these one-time mountains more slowly than the surrounding landscape because of the more resistant nature of the granite and quartzite from which they are formed.

Despite its complete remoteness, there's a hotel right in the middle of the Richat Structure.

N ↑ 21° 7' 36" N, 11° 23' 56" W 0 5km 10km

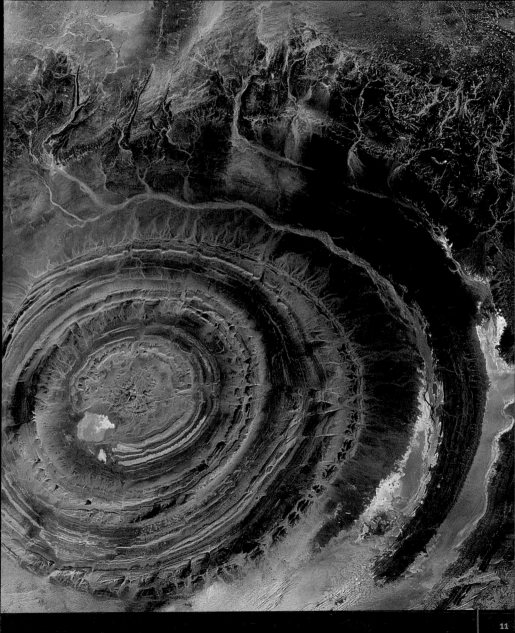

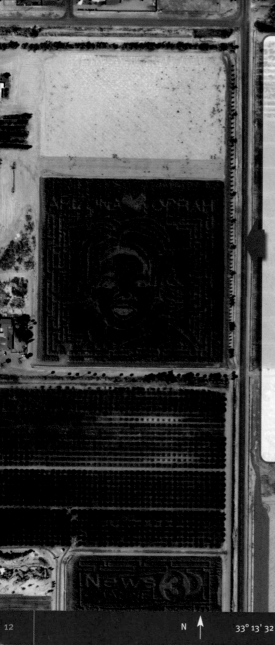

■ Arizona ♥ Oprah

Each year around Halloween, Arizona's Schnepf Farms carve a maze into their 10-acre maize field, and in 2004 they decided to celebrate Arizona's love for talk show hostess Oprah Winfrey. Schnepf Farms is the last family farm in the area, and to survive has turned from agriculture to 'entertainment, or agri-tainment'.

At different times of the year there are exciting events, including Hillbilly Bob's pig racing, banjo duels, peach festivals, the Western Sheep Dog Trials, the Country Thunder Musical Festival, and the National Helicopter Final. During each five-month season, nearly a quarter of a million people visit the farm, which is entirely organic and powered by green energy.

Oprah was chosen as 2004's cornfield personality because she 'really does make dreams come true', said Mrs Schnepf.

N

33° 13' 32" N, 111° 35' 48" W

0 100m 200m

■ Ushiku Daibutsu

Buddhism is a religion and philosophy focusing on the teachings of Siddhartha Gautama, a spiritual teacher of ancient South Asia who probably lived in the fifth century BC. Gautama is universally recognized by Buddhists as the Supreme Buddha, as it was he who last discovered the true nature of reality through 'enlightenment'.

Gautama Buddha emphasized that he was not a god, he was simply enlightened – in fact he supposedly stated that he didn't want to be worshipped. Furthermore, the Buddha didn't want himself represented in statues after his death. Nevertheless, Buddhism has a collection of the largest statues in the history of mankind, and here in Ushiku Arcadia, Japan, we can find the very tallest statue that has ever existed – Ushiku Daibutsu.

Completed in 1995, this gargantuan sculpture is an astonishing 129m tall. Ushiku Daibutsu also sits on a much smaller plinth than most other large statues – so that even if only the height of the actual figure is considered, then at 100m tall this is still the largest statue in the world.

◼ Ostankino TV Tower

Upon its completion in 1967, Moscow's 540m Ostankino TV Tower claimed the title of 'world's tallest free-standing structure', and just 7 years later, Toronto's 553.33m CN Tower stole the title away.

Moscow was displeased with losing such an important accolade, so when the Ostankino Tower was damaged by fire in 2003 they claimed to have replaced the antenna with a bigger one, increasing its height to 577m and reclaiming the title.

Sadly this was a lie – replacing the antenna would have been too expensive, and the Ostankino TV Tower is still, officially, the second tallest free-standing structure in the world.

N ↑ 55° 49' 11" N, 37° 36' 42" E 0 50m 100m

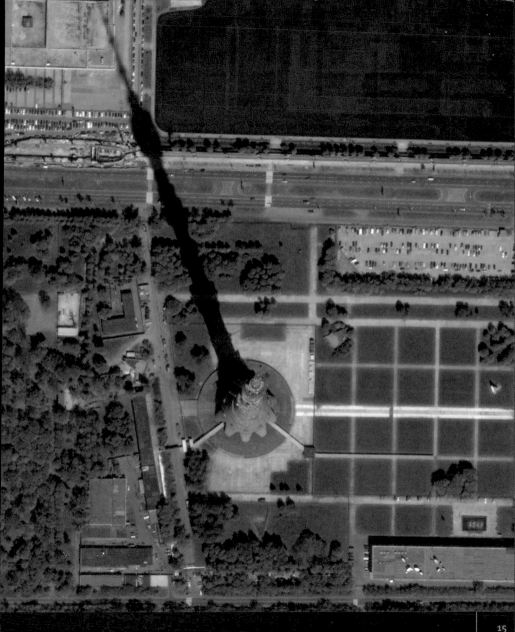

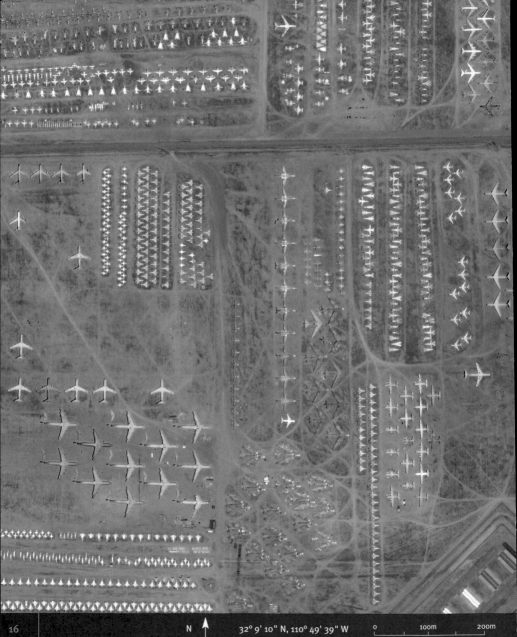

N

32° 9' 10" N, 110° 49' 39" W

0 100m 200m

■ The Boneyard

Davis Monthan Air Force Base's 'Aerospace Maintenance and Regeneration Center' is better known as 'The Boneyard', a collection of thousands of military aircraft in various states of disrepair, destruction or stasis. Amongst the collection, which is larger than the air force of any country, are A-10, F-15, F-16, C-47 and B-52 aircraft.

The desert makes for excellent storage grounds, surprisingly, as the dry air does not rust the aircraft and the hard-baked alkaline soil can support the full weight of the large planes.

The Boneyard also operates disassembly of aircraft as part of the US's requirements to destroy almost 400 B-52 bombers under the 1991 Strategic Arms Reduction Treaty (START). You can see some of these dismantled bombers in the lower right-hand corner of the picture.

Yellow Sticky Note

When word got out that we were compiling this book we were contacted by an unnamed yellow sticky note company. They told us that they were secretly developing giant 'Space-it notes' in Thailand, to allow landowners to leave themselves giant shopping lists which they can access via satellite images from anywhere in the world. The company said now that they were ready to go public with the innovation – would we like to feature it in our book?

But we turned them down and decided to feature a yellow chicken shed instead.

N 16° 23' 41" N, 103° 19' 19" E 0 50m 100m

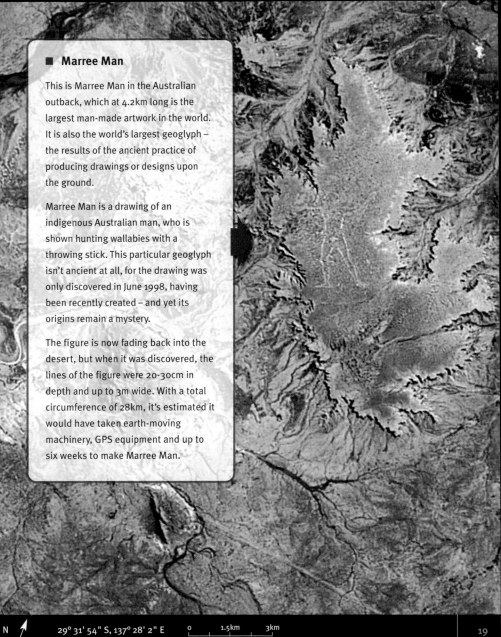

■ Marree Man

This is Marree Man in the Australian outback, which at 4.2km long is the largest man-made artwork in the world. It is also the world's largest geoglyph – the results of the ancient practice of producing drawings or designs upon the ground.

Marree Man is a drawing of an indigenous Australian man, who is shown hunting wallabies with a throwing stick. This particular geoglyph isn't ancient at all, for the drawing was only discovered in June 1998, having been recently created – and yet its origins remain a mystery.

The figure is now fading back into the desert, but when it was discovered, the lines of the figure were 20-30cm in depth and up to 3m wide. With a total circumference of 28km, it's estimated it would have taken earth-moving machinery, GPS equipment and up to six weeks to make Marree Man.

Roquefavour Aqueduct

The stunning Roquefavour Aqueduct, was completed in 1847 and designed to transport water from the River Durance to the city of Marseilles in south-east France. Based on an aqueduct designed and built by the Romans nearly 2,000 years previously, this one is 393m long and a massive 83m high, which probably makes it the tallest stone aqueduct in the world.

Unlike the much older Roman one however, the Roquefavour Aqueduct sadly hasn't lasted nearly as well – apparently it's currently closed to tourists since chunks of it started falling off after less than 150 years.

Which just proves that bigger doesn't always mean better.

N➝

43° 30' 58" N, 5° 18' 40" E

0 50m 100m

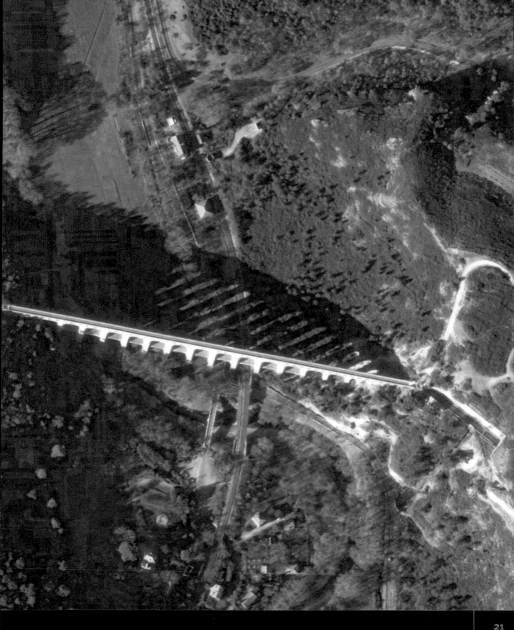

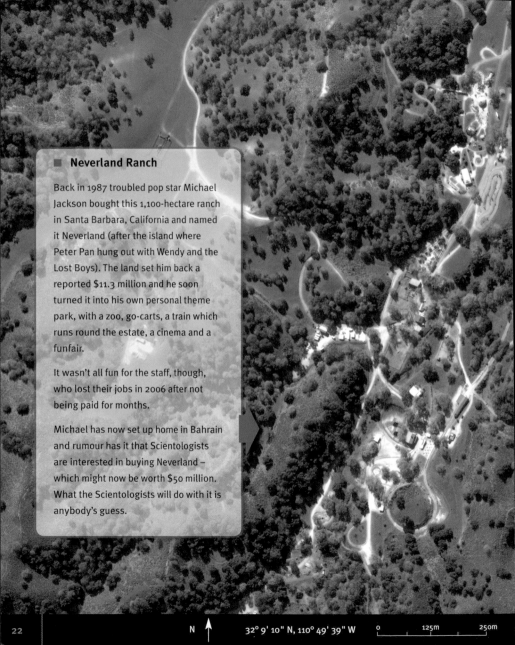

■ Neverland Ranch

Back in 1987 troubled pop star Michael Jackson bought this 1,100-hectare ranch in Santa Barbara, California and named it Neverland (after the island where Peter Pan hung out with Wendy and the Lost Boys). The land set him back a reported $11.3 million and he soon turned it into his own personal theme park, with a zoo, go-carts, a train which runs round the estate, a cinema and a funfair.

It wasn't all fun for the staff, though, who lost their jobs in 2006 after not being paid for months.

Michael has now set up home in Bahrain and rumour has it that Scientologists are interested in buying Neverland – which might now be worth $50 million. What the Scientologists will do with it is anybody's guess.

N

32° 9' 10" N, 110° 49' 39" W

0 125m 250m

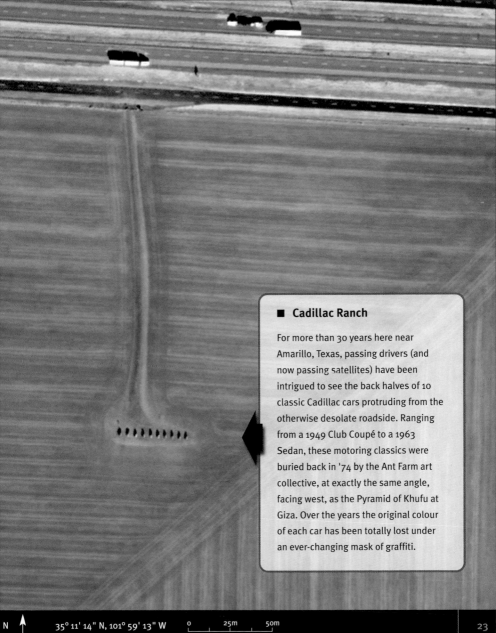

■ Cadillac Ranch

For more than 30 years here near Amarillo, Texas, passing drivers (and now passing satellites) have been intrigued to see the back halves of 10 classic Cadillac cars protruding from the otherwise desolate roadside. Ranging from a 1949 Club Coupé to a 1963 Sedan, these motoring classics were buried back in '74 by the Ant Farm art collective, at exactly the same angle, facing west, as the Pyramid of Khufu at Giza. Over the years the original colour of each car has been totally lost under an ever-changing mask of graffiti.

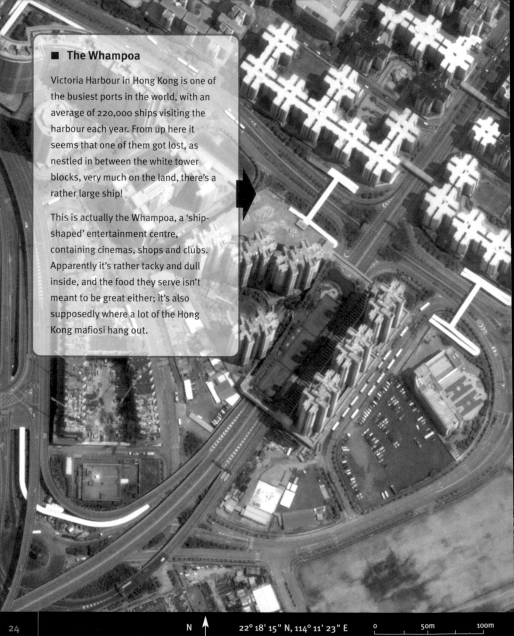

■ The Whampoa

Victoria Harbour in Hong Kong is one of the busiest ports in the world, with an average of 220,000 ships visiting the harbour each year. From up here it seems that one of them got lost, as nestled in between the white tower blocks, very much on the land, there's a rather large ship!

This is actually the Whampoa, a 'ship-shaped' entertainment centre, containing cinemas, shops and clubs. Apparently it's rather tacky and dull inside, and the food they serve isn't meant to be great either; it's also supposedly where a lot of the Hong Kong mafiosi hang out.

N

22° 18' 15" N, 114° 11' 23" E

0 50m 100m

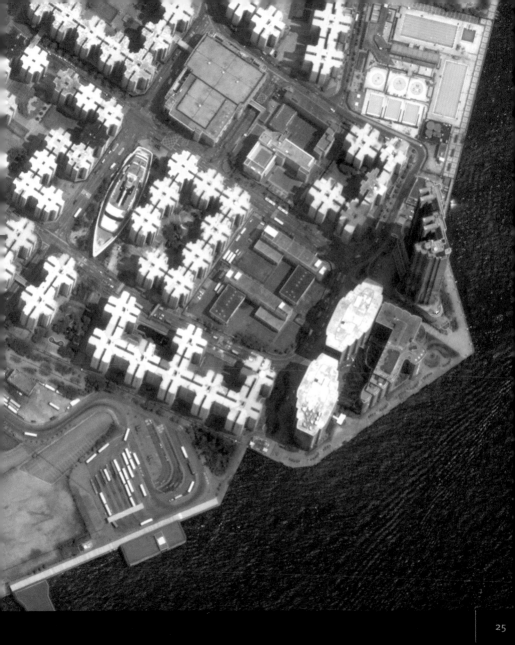

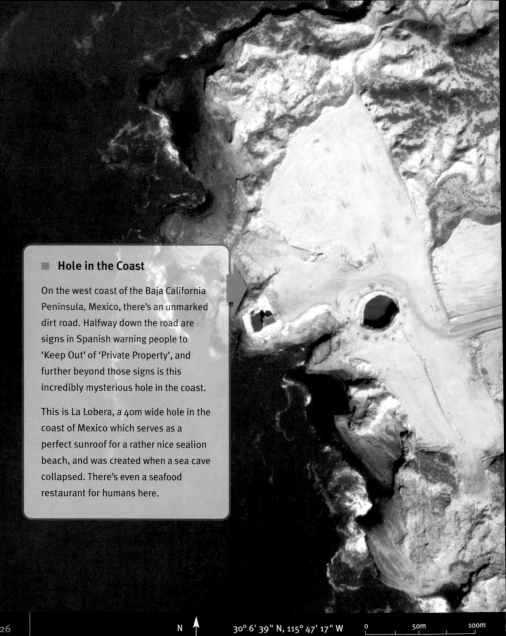

Hole in the Coast

On the west coast of the Baja California Peninsula, Mexico, there's an unmarked dirt road. Halfway down the road are signs in Spanish warning people to 'Keep Out' of 'Private Property', and further beyond those signs is this incredibly mysterious hole in the coast.

This is La Lobera, a 40m wide hole in the coast of Mexico which serves as a perfect sunroof for a rather nice sealion beach, and was created when a sea cave collapsed. There's even a seafood restaurant for humans here.

N

30° 6' 39" N, 115° 47' 17" W

0 50m 100m

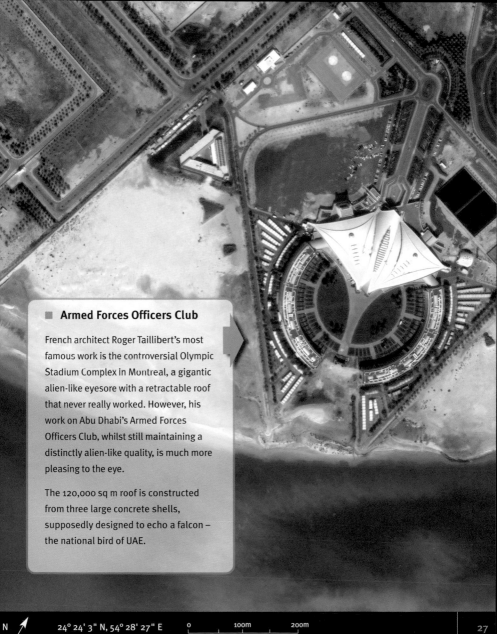

■ Armed Forces Officers Club

French architect Roger Taillibert's most famous work is the controversial Olympic Stadium Complex in Montreal, a gigantic alien-like eyesore with a retractable roof that never really worked. However, his work on Abu Dhabi's Armed Forces Officers Club, whilst still maintaining a distinctly alien-like quality, is much more pleasing to the eye.

The 120,000 sq m roof is constructed from three large concrete shells, supposedly designed to echo a falcon – the national bird of UAE.

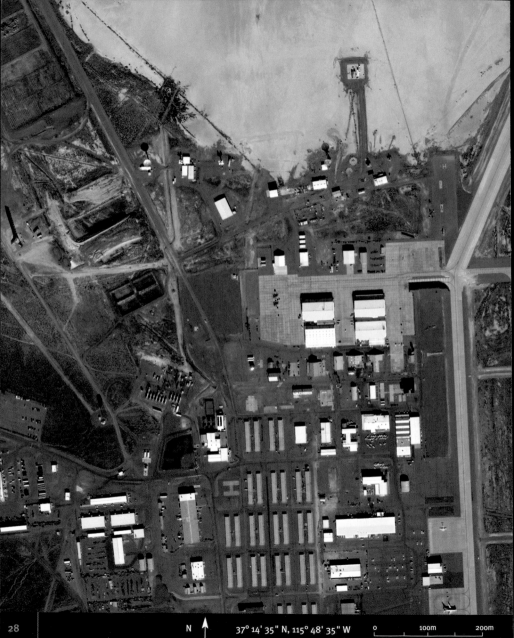

N

37° 14' 35" N, 115° 48' 35" W

0 100m 200m

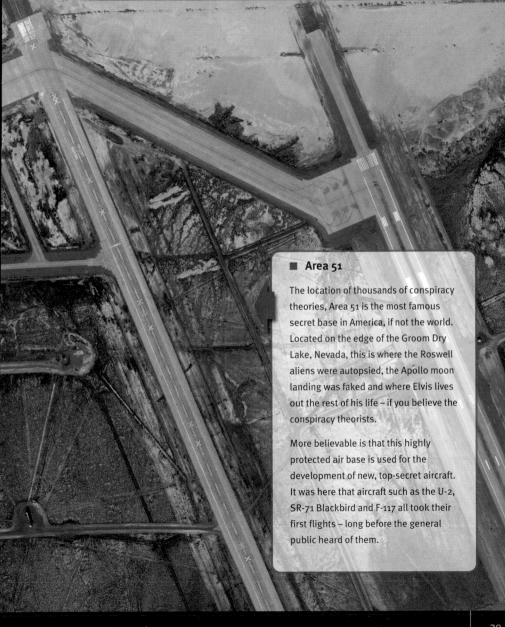

■ Area 51

The location of thousands of conspiracy theories, Area 51 is the most famous secret base in America, if not the world. Located on the edge of the Groom Dry Lake, Nevada, this is where the Roswell aliens were autopsied, the Apollo moon landing was faked and where Elvis lives out the rest of his life – if you believe the conspiracy theorists.

More believable is that this highly protected air base is used for the development of new, top-secret aircraft. It was here that aircraft such as the U-2, SR-71 Blackbird and F-117 all took their first flights – long before the general public heard of them.

Castle Peak Power Station

Castle Peak Power Station in Tuen Mun, Hong Kong is one of the largest coal-fired power stations in the world, with four units of 350MW and four of 677MW for a total output capacity of 4108MW.

The station has a unique tri-fuel firing capacity; while coal is used as the primary fuel source, the station also burns natural gas as an additional energy source and oil is used for backup and emergency startup only.

The two large tanks in the middle of this picture are marked with the Hanzi character for 'oil', and the smaller yellow tanks are marked as 'water'. This is to alert aircraft to their contents, particularly for firefighting.

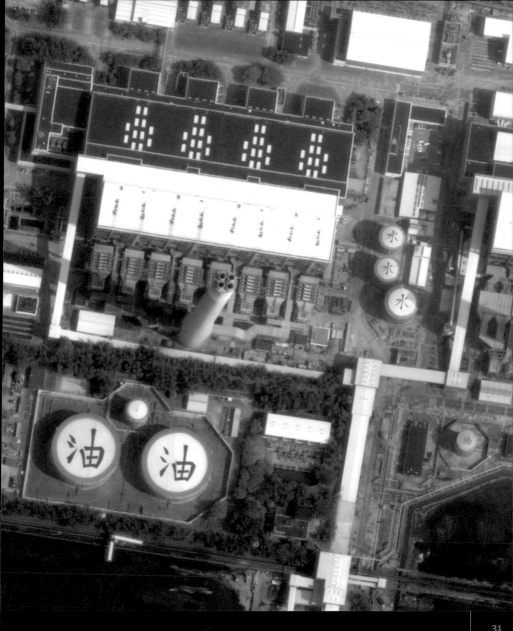

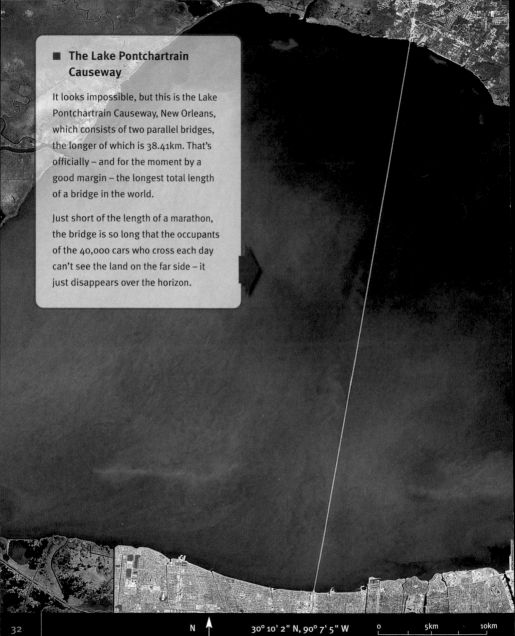

■ The Lake Pontchartrain Causeway

It looks impossible, but this is the Lake Pontchartrain Causeway, New Orleans, which consists of two parallel bridges, the longer of which is 38.41km. That's officially – and for the moment by a good margin – the longest total length of a bridge in the world.

Just short of the length of a marathon, the bridge is so long that the occupants of the 40,000 cars who cross each day can't see the land on the far side – it just disappears over the horizon.

N

30° 10' 2" N, 90° 7' 5" W

0 5km 10km

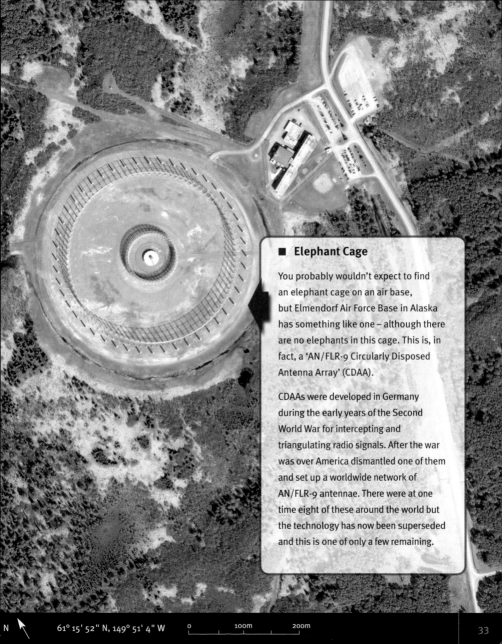

■ Elephant Cage

You probably wouldn't expect to find an elephant cage on an air base, but Elmendorf Air Force Base in Alaska has something like one – although there are no elephants in this cage. This is, in fact, a 'AN/FLR-9 Circularly Disposed Antenna Array' (CDAA).

CDAAs were developed in Germany during the early years of the Second World War for intercepting and triangulating radio signals. After the war was over America dismantled one of them and set up a worldwide network of AN/FLR-9 antennae. There were at one time eight of these around the world but the technology has now been superseded and this is one of only a few remaining.

■ Caterpillar Tractor Co.

Flying into Phoenix, Arizona on the right flight path during the last 40 years you'd have seen this 1km long sign for the 'Caterpillar Tractor Co.' Caterpillar Inc. is the world's largest manufacturer of construction and mining equipment, and this sign marked the location of the company's proving grounds for testing its products.

The sign was made by clearing vegetation and smoothing the surface (using, of course, Caterpillar vehicles) to form what might well be the largest corporate signage in the history of advertising.

Sadly, since this image was captured, the town of Verrado to the immediate north has expanded, obliterating any trace of the giant sign – with the help of ... the Caterpillar Tractor Company.

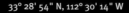

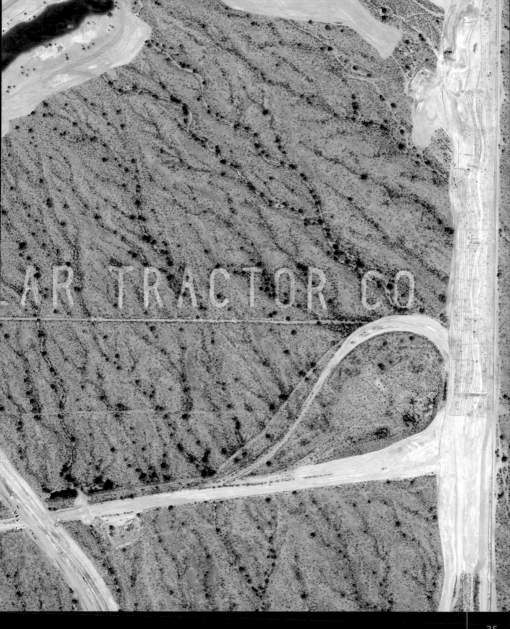

■ Face of Jesus Found in Sand Dune

Is that ... a face? This is an as yet unexplained formation in the hills outside Cuzco, Peru. It looks like ... well, that depends on your point of view, but suggestions have been made that it's:

- Simón Bolívar (Latin American revolutionary hero)
- John Lennon
- Leonardo da Vinci
- Osama bin Laden (That's where he's been hiding!)
- Gandalf
- Ki-Adi-Mundi (A Jedi master)
- Frank Zappa
- George Washington

Of course the person who appears on things most often is Jesus, who has in recent years made Himself known on a frying pan, an oyster, an asparagus root, a tortilla, a forkful of spaghetti, a fish finger, a wardrobe door, a fridge, a truck tailgate, a rose petal, several walls, an Xbox 360 packing case and virtually everything else you could possibly think of.

Actually Jesus seems to have the market cornered, as Allah and Mohammed won't do this type of public appearance.

N

0 1.5km 3km

Spiral Artwork

'Koru', this 80m wide spiral artwork, rises to 10m above the nearby lake and took New Zealand sculptor Virginia King 18 months to complete. The actual earthwork was constructed over a period of several weeks, using three 28-tonne diggers. Once shaped, the earth forms were hydro-seeded (sprayed with grass-seed and fertilizer) to establish the initial growth of grass, which is now kept in trim occasionally by sheep.

'Koru' is a Maori word for the spiral form. It is symbolic of new life, evidence that everything is reborn and continues. The Koru earth sculpture represents healing, renewal and hope for the future. The site for this work was originally a forest of ancient kauri – a magnificent tree growing to more than 50m high, with a girth of 16m, that once covered the north of New Zealand.

N ↑ 37° 24' 22" N, 116° 14' 13" W 0 100m 200m

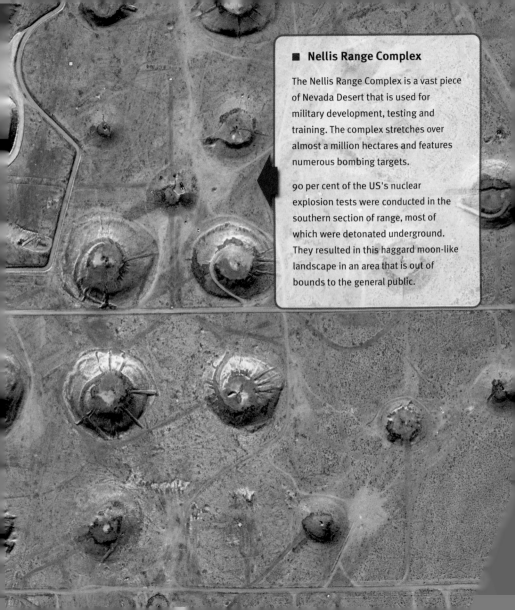

Nellis Range Complex

The Nellis Range Complex is a vast piece of Nevada Desert that is used for military development, testing and training. The complex stretches over almost a million hectares and features numerous bombing targets.

90 per cent of the US's nuclear explosion tests were conducted in the southern section of range, most of which were detonated underground. They resulted in this haggard moon-like landscape in an area that is out of bounds to the general public.

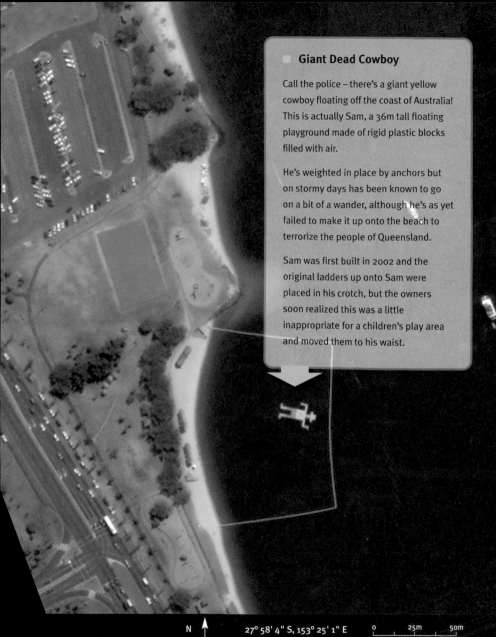

Giant Dead Cowboy

Call the police – there's a giant yellow cowboy floating off the coast of Australia! This is actually Sam, a 36m tall floating playground made of rigid plastic blocks filled with air.

He's weighted in place by anchors but on stormy days has been known to go on a bit of a wander, although he's as yet failed to make it up onto the beach to terrorize the people of Queensland.

Sam was first built in 2002 and the original ladders up onto Sam were placed in his crotch, but the owners soon realized this was a little inappropriate for a children's play area and moved them to his waist.

N

27° 58' 4" S, 153° 25' 1" E

0 25m 50m

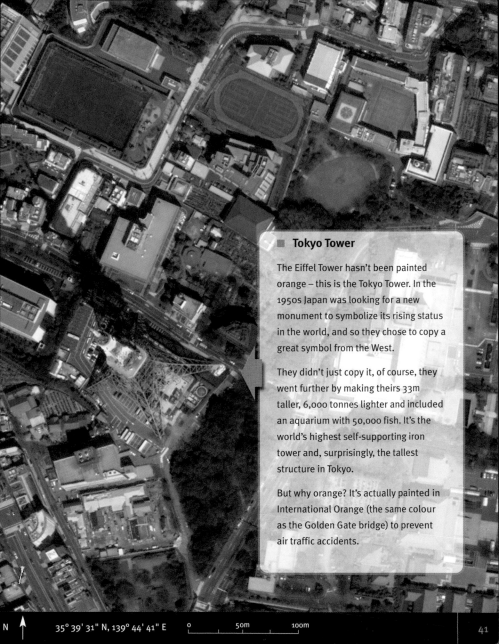

■ Tokyo Tower

The Eiffel Tower hasn't been painted orange – this is the Tokyo Tower. In the 1950s Japan was looking for a new monument to symbolize its rising status in the world, and so they chose to copy a great symbol from the West.

They didn't just copy it, of course, they went further by making theirs 33m taller, 6,000 tonnes lighter and included an aquarium with 50,000 fish. It's the world's highest self-supporting iron tower and, surprisingly, the tallest structure in Tokyo.

But why orange? It's actually painted in International Orange (the same colour as the Golden Gate bridge) to prevent air traffic accidents.

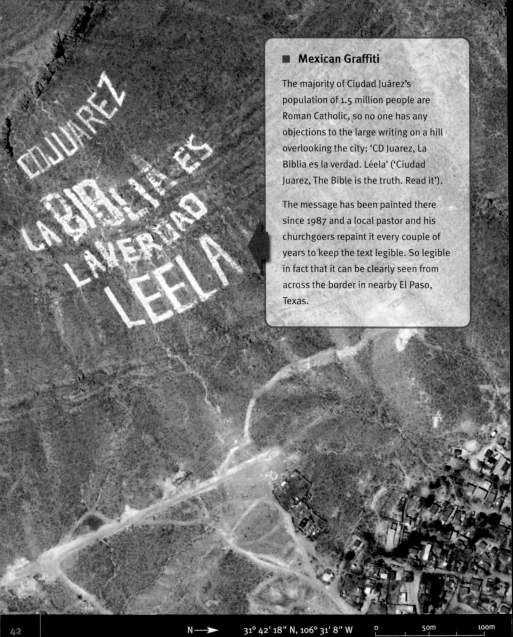

■ Mexican Graffiti

The majority of Ciudad Juárez's population of 1.5 million people are Roman Catholic, so no one has any objections to the large writing on a hill overlooking the city: 'CD Juarez, La Biblia es la verdad. Léela' ('Ciudad Juarez, The Bible is the truth. Read it').

The message has been painted there since 1987 and a local pastor and his churchgoers repaint it every couple of years to keep the text legible. So legible in fact that it can be clearly seen from across the border in nearby El Paso, Texas.

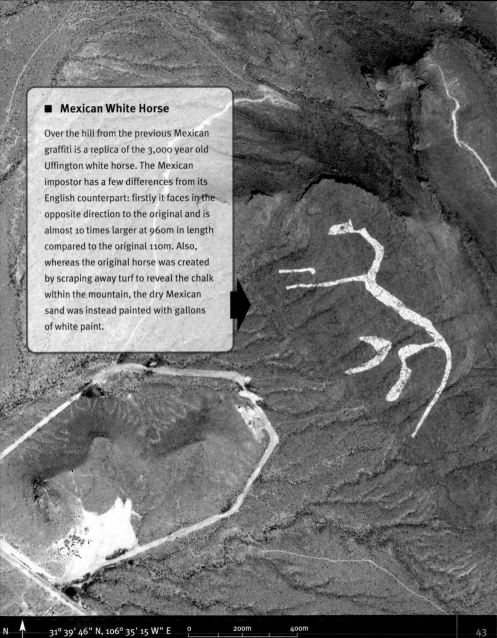

■ Mexican White Horse

Over the hill from the previous Mexican graffiti is a replica of the 3,000 year old Uffington white horse. The Mexican impostor has a few differences from its English counterpart: firstly it faces in the opposite direction to the original and is almost 10 times larger at 960m in length compared to the original 110m. Also, whereas the original horse was created by scraping away turf to reveal the chalk within the mountain, the dry Mexican sand was instead painted with gallons of white paint.

N

48° 4' 49" N, 52° 38' 53" W

0 100m 200m

■ Would You Like Some Ice With That?

This incredible image was taken off the coast of Newfoundland, Canada, on 21 March 2003. At this time of year the frozen sea water or 'pack ice' begins to melt, and the ocean currents bring the ice to eastern Canada from more northerly waters.

Each winter the Arctic seas freeze, and each spring they start to melt again, creating these country-sized slush-puppies. You can see some of the larger crunks of ice still clinging together even as they are inexorably torn apart by the movement of the water.

Pack ice plays a crucial part in the ecology of our planet, which is itself under serious threat. One of the effects of global warming is that the volume of sea ice is decreasing year on year; it's predicted that by the 2050s there will only be 54 per cent of the volume of sea ice there was in the 1950s. As the surface area of the ice decreases, so less of the sun's rays are reflected; therefore the planet becomes warmer.

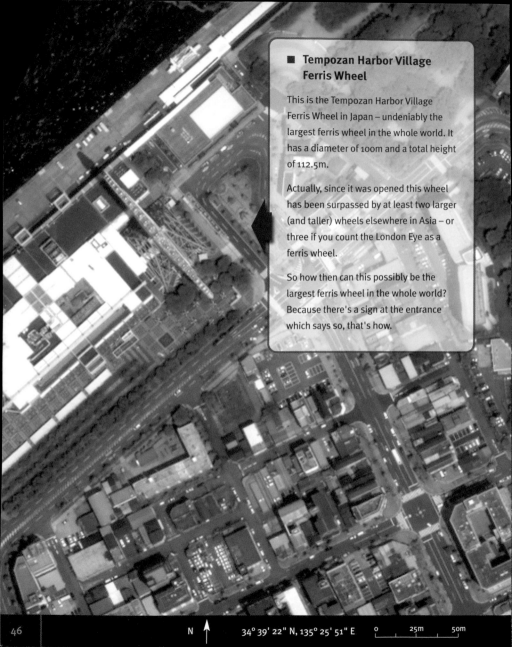

■ Tempozan Harbor Village Ferris Wheel

This is the Tempozan Harbor Village Ferris Wheel in Japan – undeniably the largest ferris wheel in the whole world. It has a diameter of 100m and a total height of 112.5m.

Actually, since it was opened this wheel has been surpassed by at least two larger (and taller) wheels elsewhere in Asia – or three if you count the London Eye as a ferris wheel.

So how then can this possibly be the largest ferris wheel in the whole world? Because there's a sign at the entrance which says so, that's how.

N ↑ 34° 39' 22" N, 135° 25' 51" E 0 25m 50m

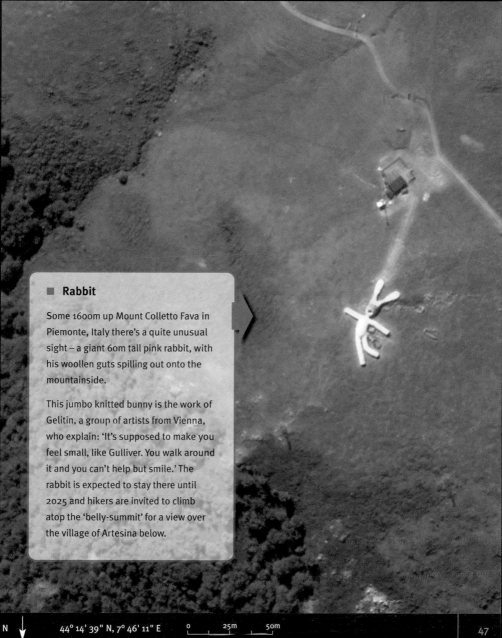

■ Rabbit

Some 1600m up Mount Colletto Fava in Piemonte, Italy there's a quite unusual sight – a giant 60m tall pink rabbit, with his woollen guts spilling out onto the mountainside.

This jumbo knitted bunny is the work of Gelitin, a group of artists from Vienna, who explain: 'It's supposed to make you feel small, like Gulliver. You walk around it and you can't help but smile.' The rabbit is expected to stay there until 2025 and hikers are invited to climb atop the 'belly-summit' for a view over the village of Artesina below.

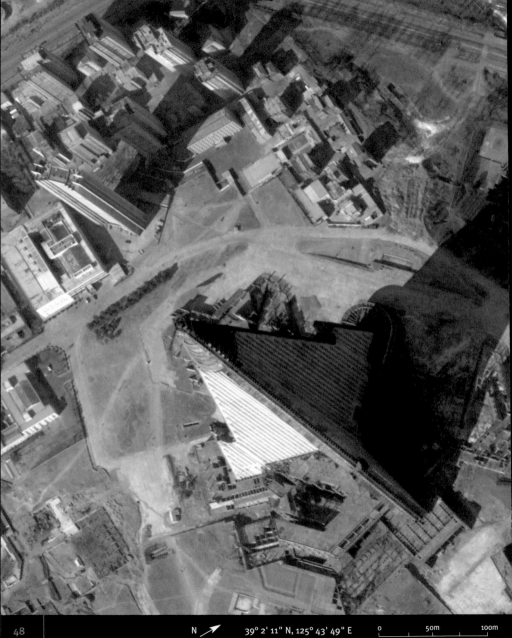

N ↗ 39° 2' 11" N, 125° 43' 49" E 0 50m 100m

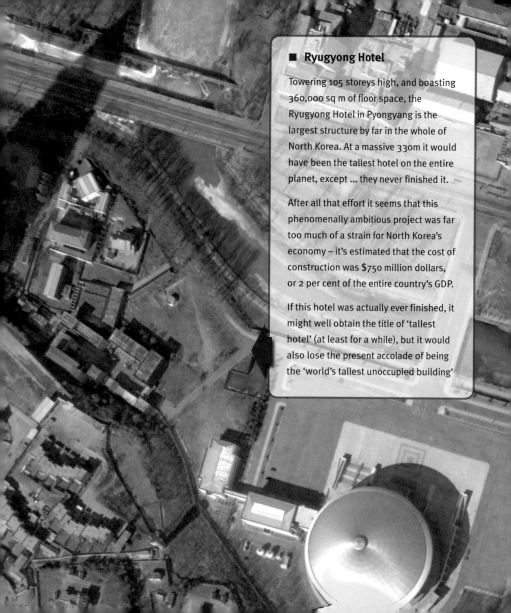

■ Ryugyong Hotel

Towering 105 storeys high, and boasting 360,000 sq m of floor space, the Ryugyong Hotel in Pyongyang is the largest structure by far in the whole of North Korea. At a massive 330m it would have been the tallest hotel on the entire planet, except ... they never finished it.

After all that effort it seems that this phenomenally ambitious project was far too much of a strain for North Korea's economy – it's estimated that the cost of construction was $750 million dollars, or 2 per cent of the entire country's GDP.

If this hotel was actually ever finished, it might well obtain the title of 'tallest hotel' (at least for a while), but it would also lose the present accolade of being the 'world's tallest unoccupied building'

■ Stealth Bomber

Parked here on the runway at Edwards Air Force Base in California is a B-2 Spirit stealth bomber, one of only 21 ever built. However, when you find out that each one cost around $2 billion to build, 21 actually seems like quite a lot.

This is the most expensive plane ever built. Apart from the obscene cost of each individual aircraft, 23 billion dollars were spent on researching the reduced infrared, acoustic, electromagnetic, visual and radar profiles of the aircraft. It is the combination of these, and other top-secret technnologies, which make this a true 'stealth' craft.

Well, except you can see it quite clearly from up here of course.

N

34° 38' 14" N, 118° 4' 55" W

0 25m 50m

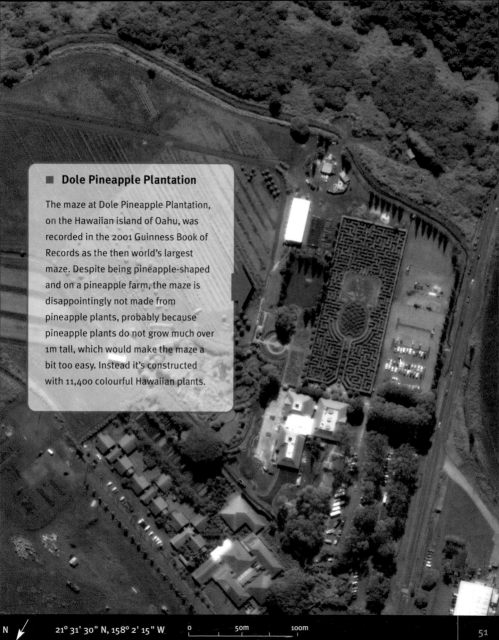

■ Dole Pineapple Plantation

The maze at Dole Pineapple Plantation, on the Hawaiian island of Oahu, was recorded in the 2001 Guinness Book of Records as the then world's largest maze. Despite being pineapple-shaped and on a pineapple farm, the maze is disappointingly not made from pineapple plants, probably because pineapple plants do not grow much over 1m tall, which would make the maze a bit too easy. Instead it's constructed with 11,400 colourful Hawaiian plants.

N

38° 4' 9" N, 122° 5' 57" W

0 100m 200m

Suisun Bay Reserve Fleet

The Suisun Bay Reserve Fleet is one of three collections of mothballed warships around the USA. The collection is mostly made up of Second World War merchant vessels which are supposedly available for use in both military and non-military emergencies within 20-120 days. However, time has taken its toll on these ships and they are becoming an environmental concern.

The rusting ships contain numerous potential problems and the obvious solution is to scrap those that are worse off, but to do so means towing them 5,000 miles to Texas, without them breaking up.

The last five ships to leave Suisun Bay for their final voyage to Texas required almost $1 million each just to make them safe for the trip. In comparison maintaining the whole fleet in their current location only costs $1.2 million per year.

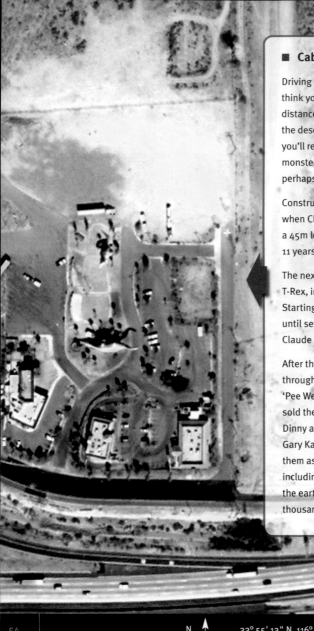

▪ Cabazon Dinosaurs

Driving along Interstate 10 you might think you're hallucinating when, in the distance, you see two dinosaurs roaming the desert. Once you get close, however, you'll realize that these concrete monsters are the Cabazon Dinosaurs, perhaps today's largest dinosaurs.

Construction began way back in 1964 when Claude Bell started with Dinny, a 45m long sauropod which took 11 years to construct, costing $250,000.

The next dinosaur was to be a 20m tall T-Rex, imaginatively called 'Rex'. Starting in 1981, work progressed well until seven years later, at the age of 91, Claude Bell sadly passed away.

After the dinosaurs became famous through their appearance in the movie 'Pee Wee's Big Adventure', Bell's family sold the prehistoric tourist attraction. Dinny and Rex are now the property of Gary Kanter, a Creationist, who is using them as a soap box for his beliefs, including the one that dinosaurs roamed the earth alongside humans only a few thousand years ago.

N ↑ 33° 55' 13" N, 116° 46' 23" W 0 35m 70m

■ RSG RULZ

If you knew a photography satellite was passing over a Nevada dry lake bed what would you do? Giant schoolboy graffiti, that's what – 'RSG RULZ'.

RSG stands for Remote Sensing Group, a very grown-up group of scientists who are part of the Optical Sciences Center at the University of Arizona, Tucson and do radiometric calibration for NASA and DigitalGlobe satellites. The team wrote their giant message while waiting for DigitalGlobe's QuickBird satellite to pass over Railroad Valley Playa for calibration.

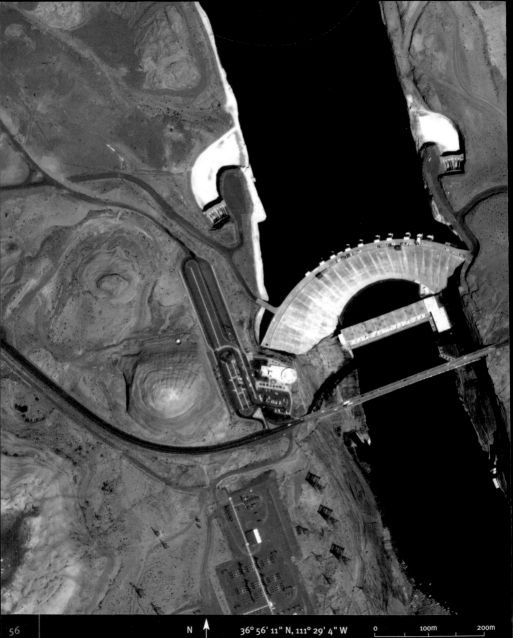

N

36º 56' 11" N, 111º 29' 4" W

0 100m 200m

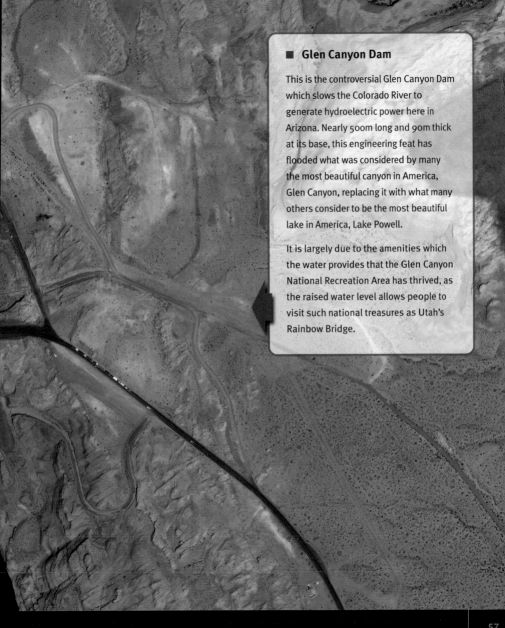

■ Glen Canyon Dam

This is the controversial Glen Canyon Dam
which slows the Colorado River to
generate hydroelectric power here in
Arizona. Nearly 500m long and 90m thick
at its base, this engineering feat has
flooded what was considered by many
the most beautiful canyon in America,
Glen Canyon, replacing it with what many
others consider to be the most beautiful
lake in America, Lake Powell.

It is largely due to the amenities which
the water provides that the Glen Canyon
National Recreation Area has thrived, as
the raised water level allows people to
visit such national treasures as Utah's
Rainbow Bridge.

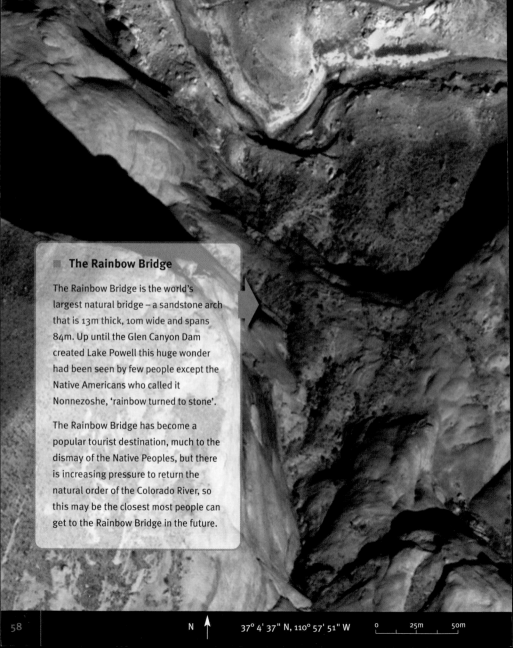

The Rainbow Bridge

The Rainbow Bridge is the world's largest natural bridge – a sandstone arch that is 13m thick, 10m wide and spans 84m. Up until the Glen Canyon Dam created Lake Powell this huge wonder had been seen by few people except the Native Americans who called it Nonnezoshe, 'rainbow turned to stone'.

The Rainbow Bridge has become a popular tourist destination, much to the dismay of the Native Peoples, but there is increasing pressure to return the natural order of the Colorado River, so this may be the closest most people can get to the Rainbow Bridge in the future.

N ↑ 37° 4' 37" N, 110° 57' 51" W 0 25m 50m

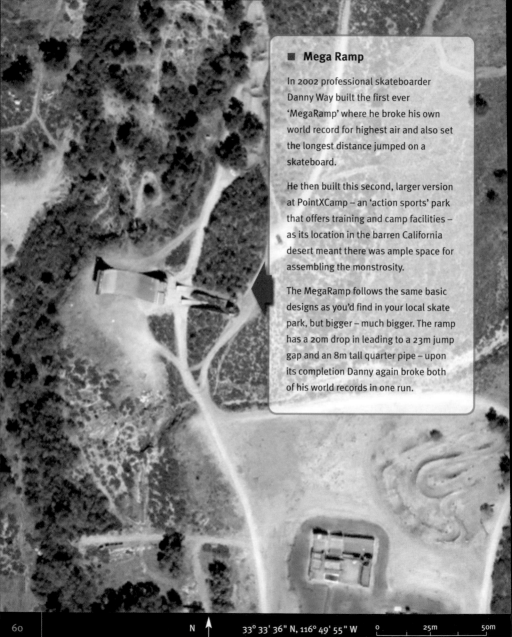

■ Mega Ramp

In 2002 professional skateboarder Danny Way built the first ever 'MegaRamp' where he broke his own world record for highest air and also set the longest distance jumped on a skateboard.

He then built this second, larger version at PointXCamp – an 'action sports' park that offers training and camp facilities – as its location in the barren California desert meant there was ample space for assembling the monstrosity.

The MegaRamp follows the same basic designs as you'd find in your local skate park, but bigger – much bigger. The ramp has a 20m drop in leading to a 23m jump gap and an 8m tall quarter pipe – upon its completion Danny again broke both of his world records in one run.

N

33° 33' 36" N, 116° 49' 55" W

0 25m 50m

■ Typhoon Class Submarines

In 1977 the Soviets began construction of a fleet of submarines that still hold the title of 'world's largest submarine' – the 941 Typhoon class. They called them Akula, meaning 'shark', but NATO referred to them as the Typhoon class.

Typhoon submarines could travel under ice and had features for ice breaking. They carried 20 long-range missiles (each with a maximum of 10 nuclear warheads), featured 6 torpedo tubes and, despite their size, were very quiet. The ships' large area meant that the crew were relatively comfortable and there was even enough space for a games room, sauna and swimming pool.

Only six were ever completed and despite their age we can see three of them in reserve service at Zapadnaya Litsa Naval Base. This picture was taken in 2004 and in the same year it was reported that the last three were to be dismantled, but they have survived that threat many times before so we can never be sure.

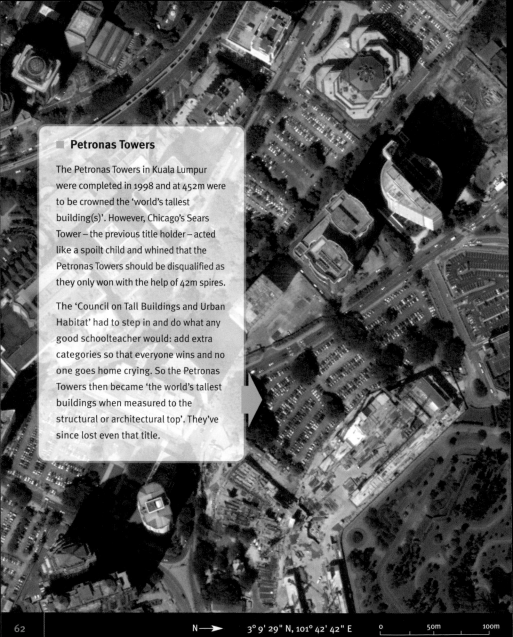

Petronas Towers

The Petronas Towers in Kuala Lumpur were completed in 1998 and at 452m were to be crowned the 'world's tallest building(s)'. However, Chicago's Sears Tower – the previous title holder – acted like a spoilt child and whined that the Petronas Towers should be disqualified as they only won with the help of 42m spires.

The 'Council on Tall Buildings and Urban Habitat' had to step in and do what any good schoolteacher would: add extra categories so that everyone wins and no one goes home crying. So the Petronas Towers then became 'the world's tallest buildings when measured to the structural or architectural top'. They've since lost even that title.

N⟶ 3° 9' 29" N, 101° 42' 42" E 0 50m 100m

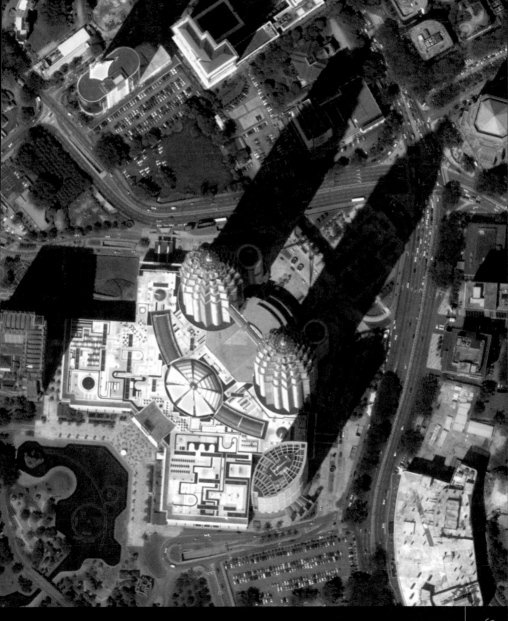

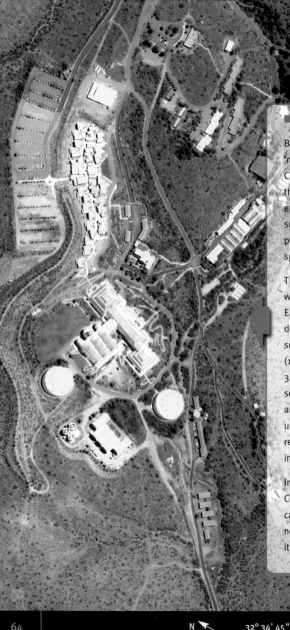

■ Biosphere 2

Biosphere 2 is a one-hectare, five-storey 'mini-earth' in the Arizona Desert. Constructed between 1987 and 1989, the ill-fated 'self-contained environment' experiment was supposedly intended to explore the possible use of closed biospheres in space colonization.

The name comes from the idea that it was modelled on 'Biosphere 1', the Earth we live on. The environment was designed to be completely self-sustaining and in the initial experiment (1991-3) eight people (or 'Bionauts') and 3,000 plants, insects and animals were sealed in the capsule. Sadly most of the animals died and microbes in the soil used up all the oxygen so that replacement oxygen had to be pumped in to keep the inhabitants alive.

In 1995 Biosphere 2 was transferred to Columbia University, which used it as a campus for a while, but the land has now been sold to a housing company so it faces an uncertain future.

N ← 32° 34' 45" N, 110° 51' 1" W

0 100m 200m

SS American Star

The *SS American Star* was built in 1936 as the *SS America* and changed her name many times before retiring as a cruise liner in 1980. For 14 years she wasted away in Greece until 1994 when she was towed to Thailand to become a floating hotel. However disaster struck while passing the Canary island of Fuerteventura where a strong storm beached the ship and broke her in two.

The ship's bow now sits on a flat rock, while the stern tore away and sank into deeper water to the south. A tropical storm in November 2005 worsened the position of the bow and local residents doubt it will last the winter of 2006.

Still, the legacy of the *SS American Star* will live on - soon after beaching locals took all they could from the ship and in Fuerteventura's capital of Puerto del Rosario 'Cafeteria el Naufragio' is completely fitted out with doors, panelling, portholes and furniture from the *SS American Star*.

28° 20' 46" N, 14° 10' 50" W

0 62.5m 125m

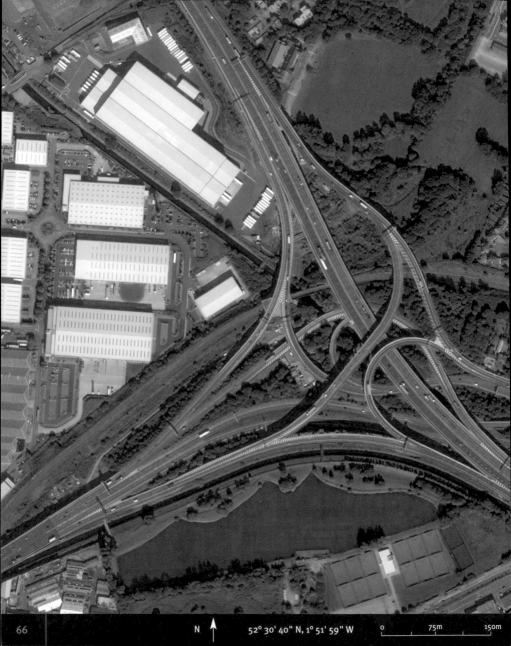

N

52° 30' 40" N, 1° 51' 59" W

0 75m 150m

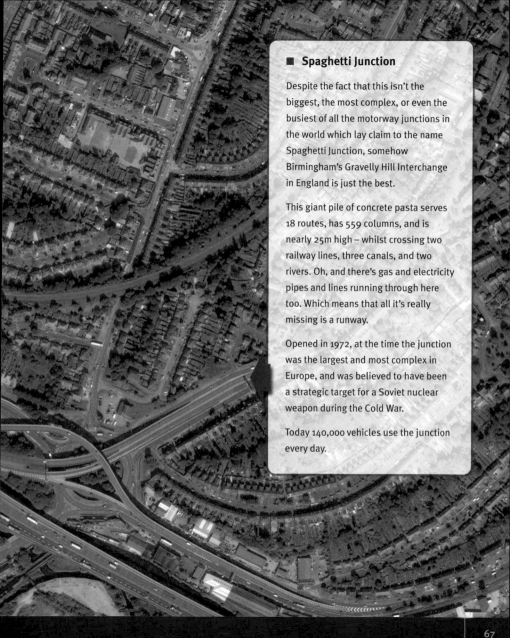

■ Spaghetti Junction

Despite the fact that this isn't the biggest, the most complex, or even the busiest of all the motorway junctions in the world which lay claim to the name Spaghetti Junction, somehow Birmingham's Gravelly Hill Interchange in England is just the best.

This giant pile of concrete pasta serves 18 routes, has 559 columns, and is nearly 25m high – whilst crossing two railway lines, three canals, and two rivers. Oh, and there's gas and electricity pipes and lines running through here too. Which means that all it's really missing is a runway.

Opened in 1972, at the time the junction was the largest and most complex in Europe, and was believed to have been a strategic target for a Soviet nuclear weapon during the Cold War.

Today 140,000 vehicles use the junction every day.

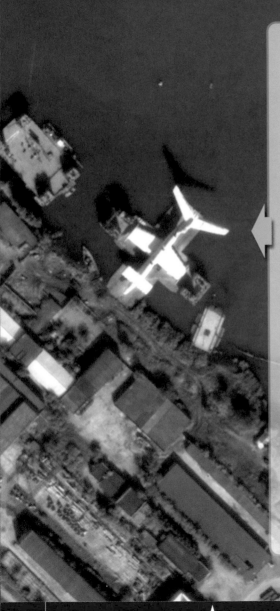

Hen Harrier

When the US military first saw secret pictures of Ekranoplans in 1963 they didn't have a clue what they were. The craft had been developed under conditions of extreme secrecy at the height of the Cold War. An Ekranoplan ('surface-plane' in Russian) is a plane-ship hybrid that can skim over the water using the upward force of the WiG (Wing in Ground) effect, which forms a cushion of air under the short but very wide wing. Various models of Ekranoplan were used by the Soviet and Russian navies from 1987 to the late 1990s.

The craft seen here is a Lun ('Harrier') MD-160, which entered service with the Black Sea Fleet in 1987.

It should be a fantastic mode of travel, because Ekranoplans are much faster than boats. They can fly over water, beaches, deserts, snow, glaciers or grassland, and are safer than planes – if the engines fail they can land on the water and sail like ordinary ships.

So why aren't Ekranoplans everywhere? Amazingly, the problem with the Lun was that it was just too small for the ground effect to work sufficiently well.

N 42° 52' 55" N, 47° 39' 24" E 0 25m 50m

■ Airplane Home

Here in Portland, Oregon, just a stone's throw from local homes, is the fuselage of a rather special aircraft peeking out from under the treetops. It hasn't crashed here though – it was carefully transported here piece by piece by its current owner, who has spent a small fortune converting this ex-passenger plane into ... his house.

The plane is actually a Boeing 727-200, a mid-size, commercial aircraft which first took to the skies in 1963 and was the best-selling airliner in the world during the first 30 years of jet transport service. There were 1,831 delivered while the 727 remained in production, which means that there are plenty of them available if you want to build your very own home in one.

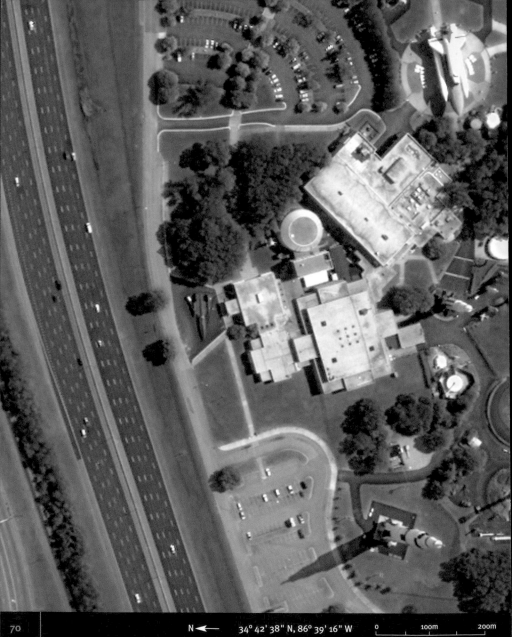

N ◀— 34° 42' 38" N, 86° 39' 16" W

0 100m 200m

■ US Space and Rocket Center

Here at the US Space & Rocket Center in Huntsville, Alabama, they have more than 1,500 bits of rocket and space hardware on display. There's been a museum on this site since 1970, when it was decided to showcase some of the more interesting relics from the US space programme.

Beside the road you can see a Lockheed A-12 single-seater reconnaissance aircraft – that's a spy plane to you and me.

You should be able to spot an actual-size mock-up of the Shuttle and its solid rocket boosters, but that's not the most impressive thing here.

Clearly visible lying on the ground is an actual Saturn V rocket, one of the series that was used to carry the Apollo missions into space, and also to deliver the Skylab space station into orbit. This truly incredible machine is the most powerful launch vehicle ever used, and at over 110m tall is almost exactly the same height as St Paul's Cathedral.

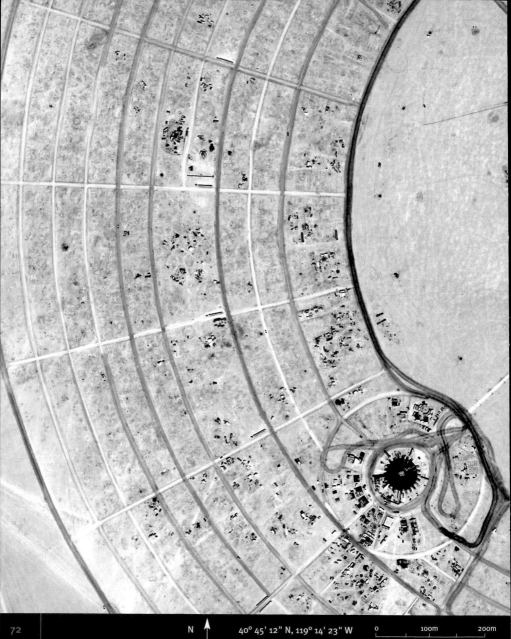

N

40° 45' 12" N, 119° 14' 23" W

0 100m 200m

■ Black Rock City

This photograph was taken shortly before the start of the annual week-long Burning Man festival, which takes place in the middle of the Nevada desert each year. The arc shapes drawn into the sand are markers for where streets will be formed as anything up to 40,000 revellers arrive here to help create what is temporarily, America's most densely populated place: Black Rock City.

The event culminates in the burning of a large wooden sculpture of a man. In our photo you can see that the main hub of the city, Center Camp, is starting to be formed – and right in the centre of the complex they've started to build the wooden man too. By the time it's all over and everyone involved has left there should be no trace of this place remaining – the participants are required to take responsibility for themselves and take away every single thing they brought with them, hopefully allowing the desert to remain unspoilt by their yearly intrusion.

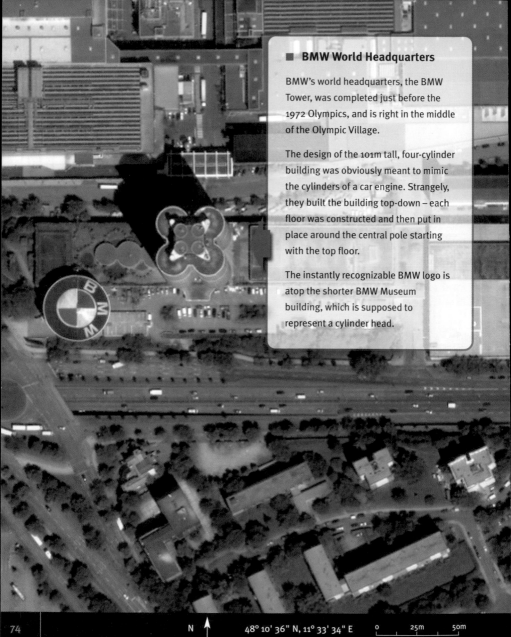

■ BMW World Headquarters

BMW's world headquarters, the BMW Tower, was completed just before the 1972 Olympics, and is right in the middle of the Olympic Village.

The design of the 101m tall, four-cylinder building was obviously meant to mimic the cylinders of a car engine. Strangely, they built the building top-down – each floor was constructed and then put in place around the central pole starting with the top floor.

The instantly recognizable BMW logo is atop the shorter BMW Museum building, which is supposed to represent a cylinder head.

N

48° 10' 36" N, 11° 33' 34" E

0 25m 50m

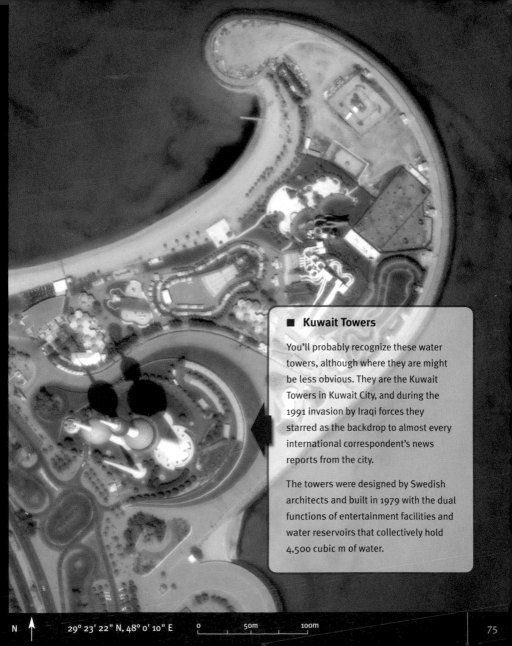

■ Kuwait Towers

You'll probably recognize these water towers, although where they are might be less obvious. They are the Kuwait Towers in Kuwait City, and during the 1991 invasion by Iraqi forces they starred as the backdrop to almost every international correspondent's news reports from the city.

The towers were designed by Swedish architects and built in 1979 with the dual functions of entertainment facilities and water reservoirs that collectively hold 4,500 cubic m of water.

N 29° 23' 22" N, 48° 0' 10" E 0 50m 100m

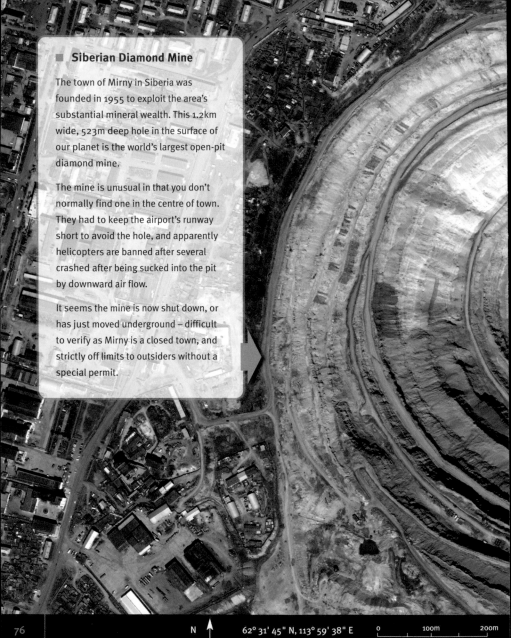

■ Siberian Diamond Mine

The town of Mirny in Siberia was founded in 1955 to exploit the area's substantial mineral wealth. This 1.2km wide, 523m deep hole in the surface of our planet is the world's largest open-pit diamond mine.

The mine is unusual in that you don't normally find one in the centre of town. They had to keep the airport's runway short to avoid the hole, and apparently helicopters are banned after several crashed after being sucked into the pit by downward air flow.

It seems the mine is now shut down, or has just moved underground – difficult to verify as Mirny is a closed town, and strictly off limits to outsiders without a special permit.

N

62° 31' 45" N, 113° 59' 38" E

0 100m 200m

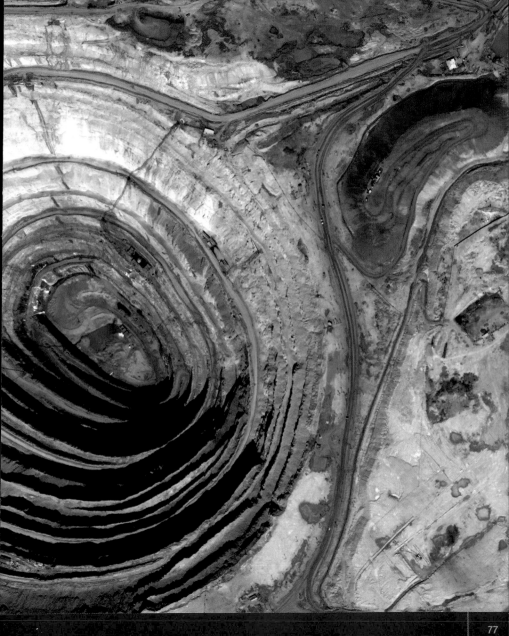

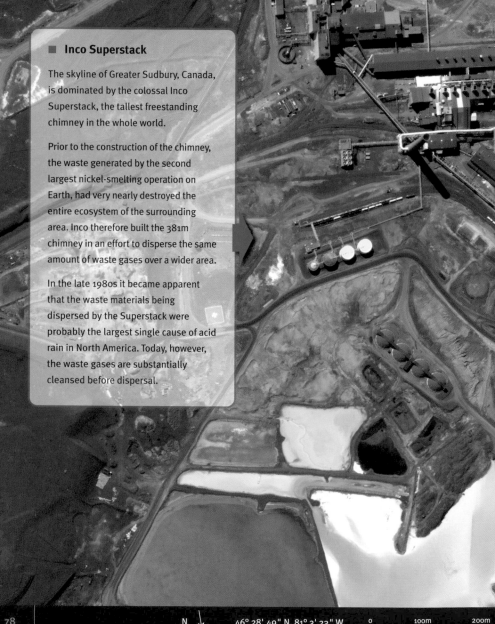

■ Inco Superstack

The skyline of Greater Sudbury, Canada, is dominated by the colossal Inco Superstack, the tallest freestanding chimney in the whole world.

Prior to the construction of the chimney, the waste generated by the second largest nickel-smelting operation on Earth, had very nearly destroyed the entire ecosystem of the surrounding area. Inco therefore built the 381m chimney in an effort to disperse the same amount of waste gases over a wider area.

In the late 1980s it became apparent that the waste materials being dispersed by the Superstack were probably the largest single cause of acid rain in North America. Today, however, the waste gases are substantially cleansed before dispersal.

N

46° 28' 49" N, 81° 3' 23" W

0 100m 200m

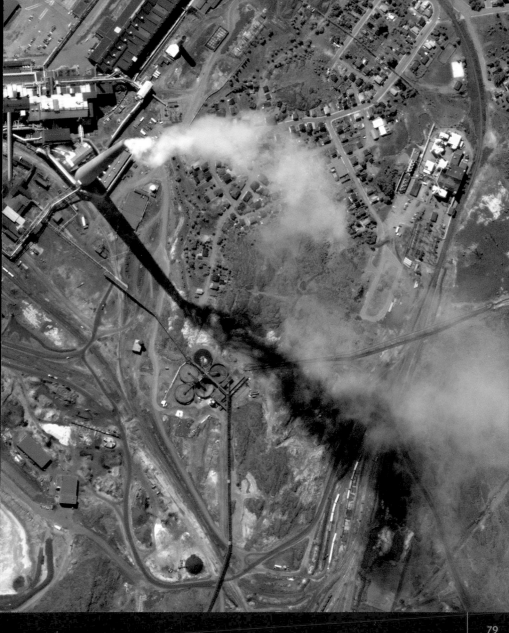

■ Jump Towers

These odd structures are 'Jump Towers', used by students at the US Army Airborne School to practise parachute landing. Trainees are hooked into a harness and hauled to the top of the tower, before being dropped 76m towards the ground below. Many believe the story that the towers were moved here from Coney Island where a parachute tower was installed for the 1939 NY World's fair. The claim is easily disproved though, as the parachute tower is still standing on Coney Island. The design of these towers was in fact based on the Coney Island tower. Four of them were erected here between 1941 and 1942. In 1954 a tornado destroyed one of the towers so that three remain, while only two are still in use.

N

32° 21' 27" N, 84° 58' 14" W

0 62.5m 125m

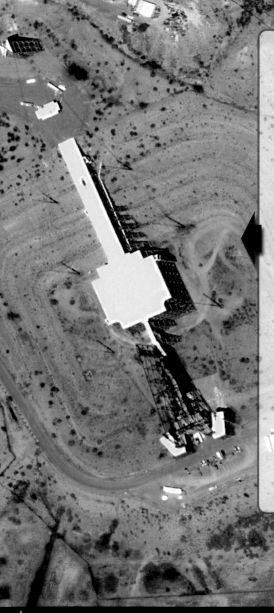

■ TRESTLE

Large structures are usually associated with steel beams, nuts and bolts, and rivets, but the 38m tall TRESTLE electromagnetic pulse simulator is entirely metal-free and is the world's largest glued-laminated wood structure.

Located at Kirtland Air Force Base, the $60 million structure is used to test an aircraft's resilience to electromagnetic pulses (EMPs). Aircraft are manoeuvred up the 117m ramp to the 18 sq m platform and tethered there before a simulated EMP of 10 million volts is launched from the specially designed antennae.

EMPs are capable of knocking out all unshielded electrical equipment within a large radius and could potentially be used in a terrorist attack – which is why it is so important to make sure that military aircraft can survive EMPs as much as possible.

The TRESTLE platform had to be made from wood as any metal would cause electrical interference and ruin the tests.

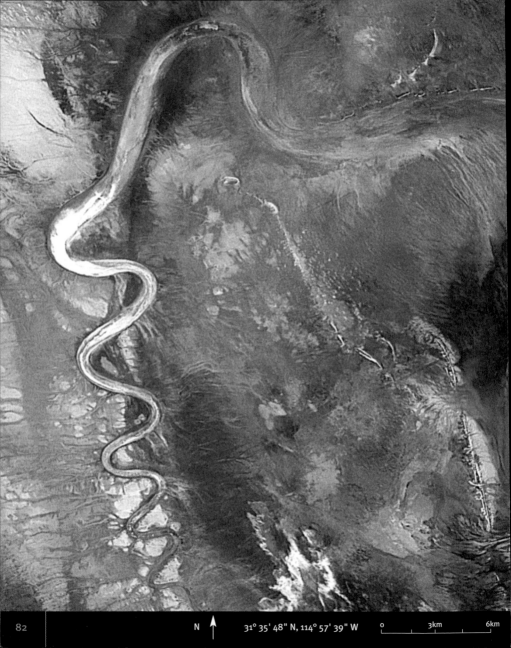

N ↑ 31° 35' 48" N, 114° 57' 39" W 0 3km 6km

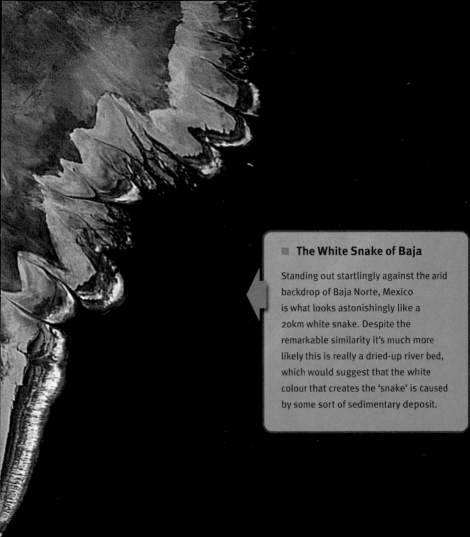

The White Snake of Baja

Standing out startlingly against the arid backdrop of Baja Norte, Mexico is what looks astonishingly like a 20km white snake. Despite the remarkable similarity it's much more likely this is really a dried-up river bed, which would suggest that the white colour that creates the 'snake' is caused by some sort of sedimentary deposit.

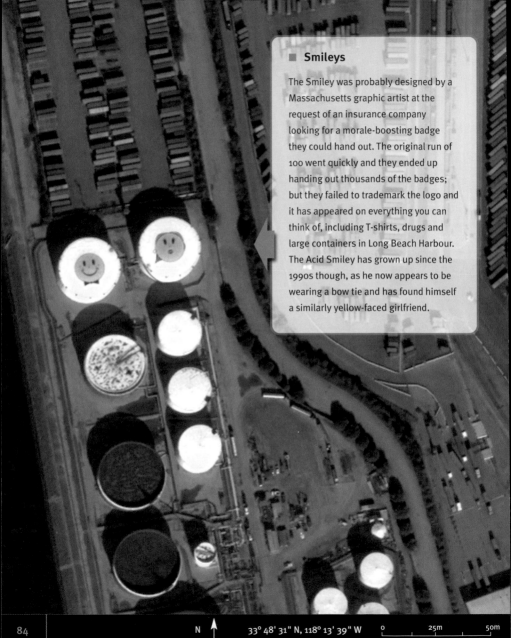

■ Smileys

The Smiley was probably designed by a Massachusetts graphic artist at the request of an insurance company looking for a morale-boosting badge they could hand out. The original run of 100 went quickly and they ended up handing out thousands of the badges; but they failed to trademark the logo and it has appeared on everything you can think of, including T-shirts, drugs and large containers in Long Beach Harbour. The Acid Smiley has grown up since the 1990s though, as he now appears to be wearing a bow tie and has found himself a similarly yellow-faced girlfriend.

■ Slab City

It doesn't look much like it but this abandoned Second World War Marine training base in the California desert has become an unofficial city. Named 'Slab City' after the concrete slabs which were left by the Marines, it has no running water, electricity or sewage, yet is home to up to 3,000 people, depending on the time of year.

Those living here range from rich RV owners to poor runaways and dropouts, yet there's a community spirit among the squatters who have a noticeboard, library, pet cemetery, night club, website, an 18-hole golf course and a single makeshift shower.

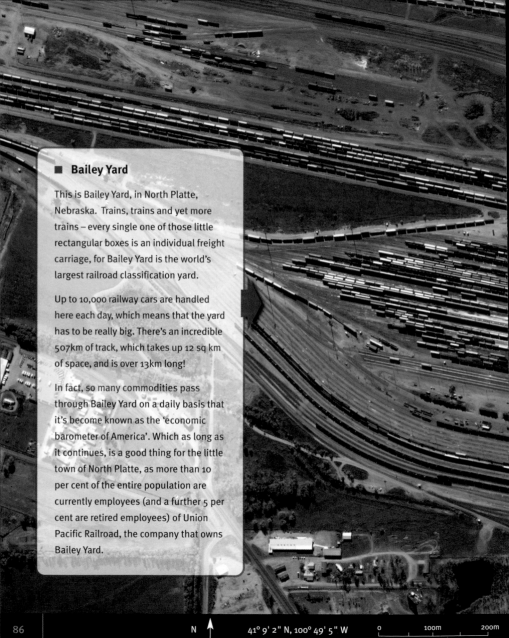

■ Bailey Yard

This is Bailey Yard, in North Platte, Nebraska. Trains, trains and yet more trains – every single one of those little rectangular boxes is an individual freight carriage, for Bailey Yard is the world's largest railroad classification yard.

Up to 10,000 railway cars are handled here each day, which means that the yard has to be really big. There's an incredible 507km of track, which takes up 12 sq km of space, and is over 13km long!

In fact, so many commodities pass through Bailey Yard on a daily basis that it's become known as the 'economic barometer of America'. Which as long as it continues, is a good thing for the little town of North Platte, as more than 10 per cent of the entire population are currently employees (and a further 5 per cent are retired employees) of Union Pacific Railroad, the company that owns Bailey Yard.

N

41° 9' 2" N, 100° 49' 5" W

0 100m 200m

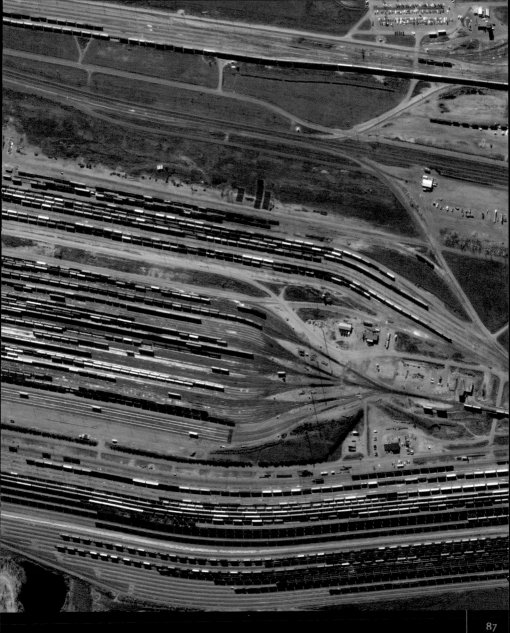

■ Trippy Triangle

More weirdness at the Nellis Range Complex (see page 38) – the stretch of the Nevada Desert used for military development, testing, training and aerial bombing. Information on the area is obviously classified, and when we contacted people involved in the testing they acted like we were utterly mad to claim there were giant triangles drawn on the desert floor. The proof is clearly visible here however, and at 1.2km across it's rather hard to miss.

N ↑ 37° 37' 41" N, 116° 50' 54" W 0 100m 200m

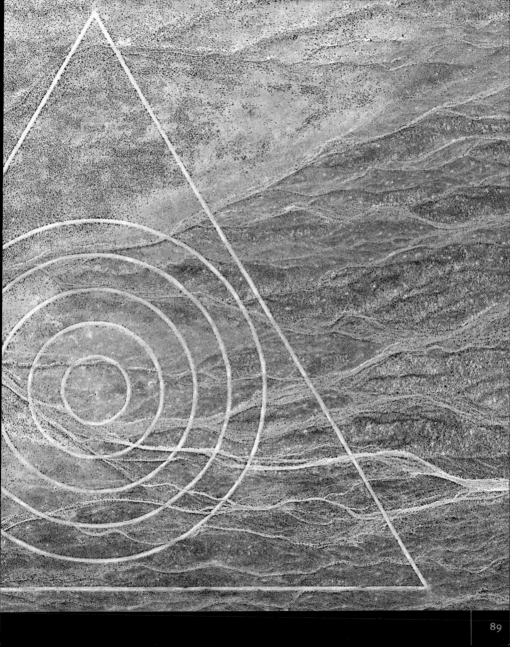

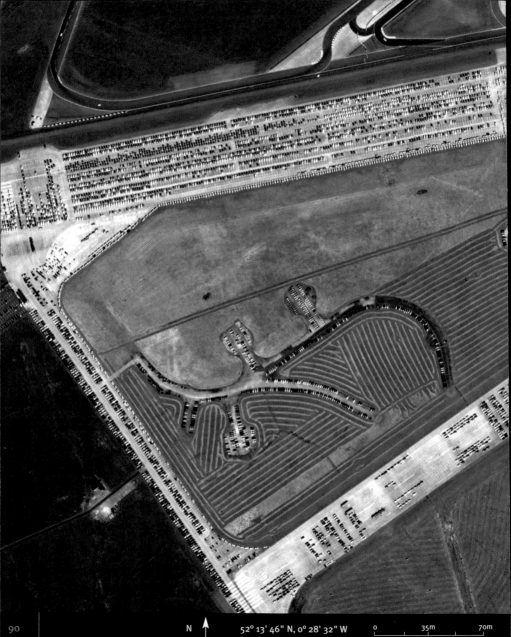

N

52° 13' 46" N, 0° 28' 32" W

0 35m 70m

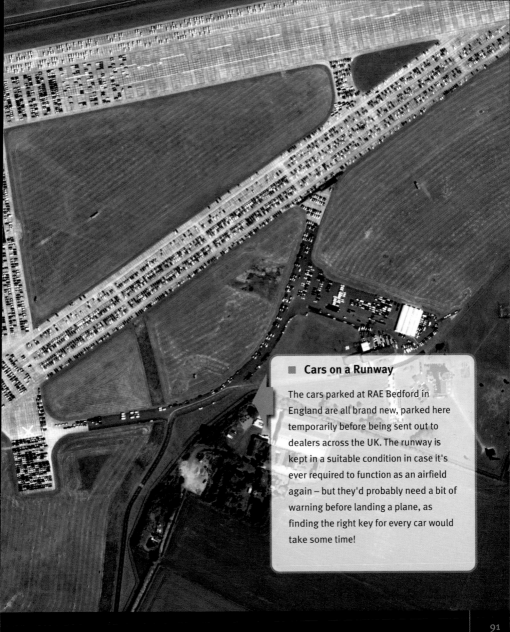

■ **Cars on a Runway**

The cars parked at RAE Bedford in England are all brand new, parked here temporarily before being sent out to dealers across the UK. The runway is kept in a suitable condition in case it's ever required to function as an airfield again – but they'd probably need a bit of warning before landing a plane, as finding the right key for every car would take some time!

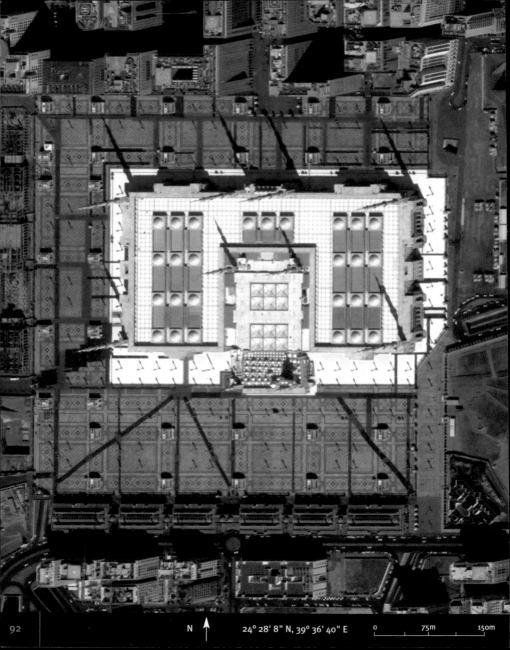

N ↑ 24° 28' 8" N, 39° 36' 40" E 0 75m 150m

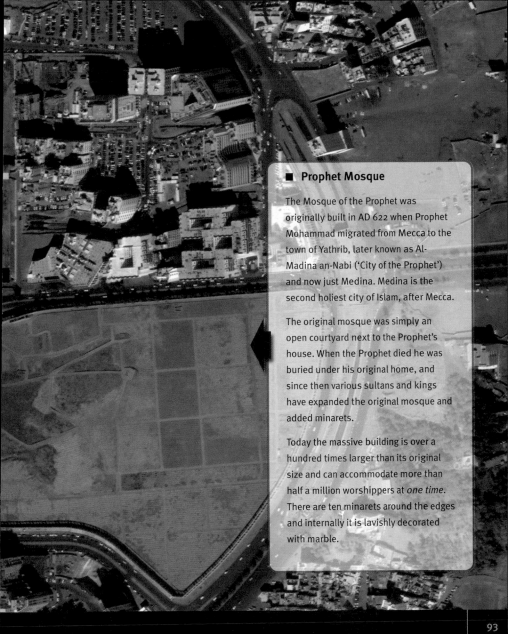

■ Prophet Mosque

The Mosque of the Prophet was originally built in AD 622 when Prophet Mohammad migrated from Mecca to the town of Yathrib, later known as Al-Madina an-Nabi ('City of the Prophet') and now just Medina. Medina is the second holiest city of Islam, after Mecca.

The original mosque was simply an open courtyard next to the Prophet's house. When the Prophet died he was buried under his original home, and since then various sultans and kings have expanded the original mosque and added minarets.

Today the massive building is over a hundred times larger than its original size and can accommodate more than half a million worshippers at *one time*. There are ten minarets around the edges and internally it is lavishly decorated with marble.

■ The Gas Tank

Just south of Boston in Dorchester, Massachusetts sits a 45m tall liquefied natural gas tank which claims the odd title of 'world's largest copyrighted artwork'.

Back in 1971 Boston Gas commissioned Corita Kent, also known as Sister Corita, to paint one of their two giant gas tanks near Logan International Airport. Kent, a former nun, usually worked with serigraphy (silk-screening) and her artwork often featured themes of love and peace. This was during the Vietnam War and it is alleged that, as an active war protester, Corita designed the blue stripe of the gas tank to be a profile of Ho Chi Minh.

In 1992 the gas tank was torn down but Corita's design was repainted on the tank's previously dull neighbour. Despite both Boston Gas and Corita herself denying the likeness to Ho Chi Minh, the blue stripe was slightly adjusted when transferred to the second tank – making it look a bit less like Ho.

N ← 42° 18' 6" N, 71° 2' 44" W 0 25m 50m

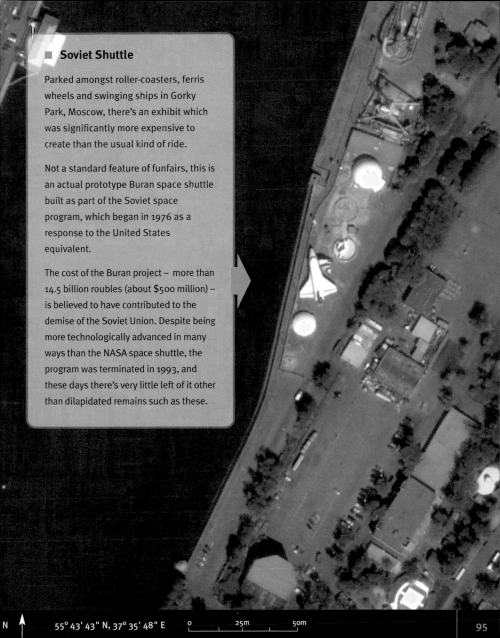

Soviet Shuttle

Parked amongst roller-coasters, ferris wheels and swinging ships in Gorky Park, Moscow, there's an exhibit which was significantly more expensive to create than the usual kind of ride.

Not a standard feature of funfairs, this is an actual prototype Buran space shuttle built as part of the Soviet space program, which began in 1976 as a response to the United States equivalent.

The cost of the Buran project – more than 14.5 billion roubles (about $500 million) – is believed to have contributed to the demise of the Soviet Union. Despite being more technologically advanced in many ways than the NASA space shuttle, the program was terminated in 1993, and these days there's very little left of it other than dilapidated remains such as these.

■ LUECKE

A 'point' is a unit of measurement in typography. For example, the text you are reading now is 7.5 points, and the title of this page is 9 points. In the image, the text is approximately 2.5 million points – probably the largest writing in the history of the world. In fact these letters are so huge that NASA astronauts now use them to help calibrate their photography equipment!

So what on earth is it doing here? The story goes the local landowner wanted to clear an area of land for grazing, but the law stated that he needed to keep a certain percentage of the tree growth to maintain healthy wildlife habitats and to prevent erosion – so he decided to leave the uncleared areas in a pattern that spelled out his surname, Luecke.

A dubious story indeed, and one which sounds even more unlikely when you hear that the first four holes of a golf course are located inside the letter 'L'.

N ◀— 30º 4' 54" N, 97º 8' 28" W 0 1.5km 3km

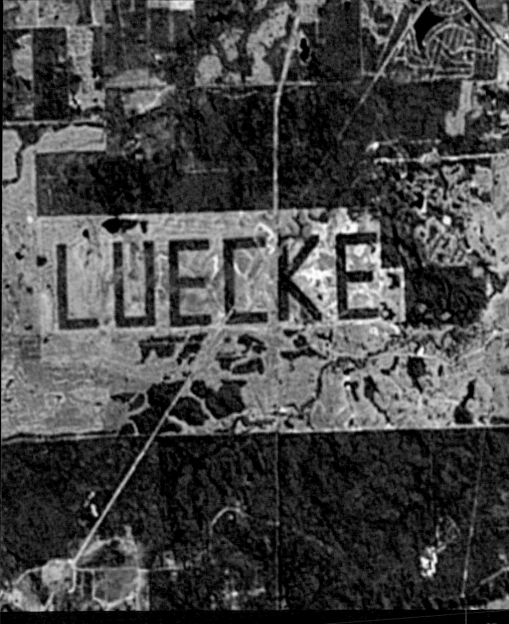

■ Ocean Plug Holes

Just off the east coast off Spain lies this collection of holes in the sea. They're used to drain the Mediterranean, which allows for regular cleaning of the seabed – honestly!

OK, so if they're not really ocean plugholes then what are they? Aliens? Genetically modified barnacles? Giant fishnet stockings? Suckers on the arm of a giant squid? The world's largest Lego brick? A full-sized game of Battleships?

Still unconvinced? Well it couldn't possibly be a fish farm.

N

40° 13' 54" N, 0° 17' 59" E

0 50m 100m

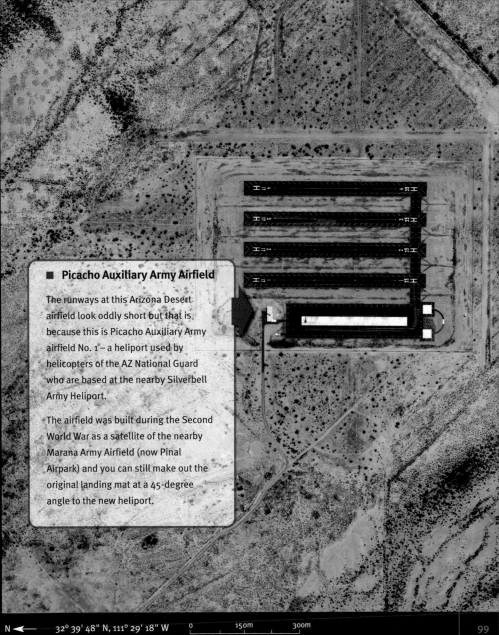

■ Picacho Auxiliary Army Airfield

The runways at this Arizona Desert airfield look oddly short but that is because this is Picacho Auxiliary Army airfield No. 1 – a heliport used by helicopters of the AZ National Guard who are based at the nearby Silverbell Army Heliport.

The airfield was built during the Second World War as a satellite of the nearby Marana Army Airfield (now Pinal Airpark) and you can still make out the original landing mat at a 45-degree angle to the new heliport.

GO NAVY

The US Navy's west coast LCAC hovercraft fleet are parked at a coastal military base. 'Landing Craft, Air Cushion' amphibious landing craft are basically special hovercraft which the navy uses to transfer tanks, troops and equipment from ship to shore. They are each 26m long, weigh 200 tonnes and can travel at 40 knots with a payload.

The base consists of a 610m x 365m parking area where the hovercraft are usually stored, along with four hangars and a runway which leads out onto the sea for quick departure. There is also a control tower on the beachfront, which operates just like an airport control tower, managing the flow of traffic up and down the runway. The base is located on the site of a former military airfield, and presumably its close proximity to other airfields is why they painted 'GO NAVY' on the tarmac.

N

33° 15' 33" N, 117° 26' 1" W

0 50m 100m

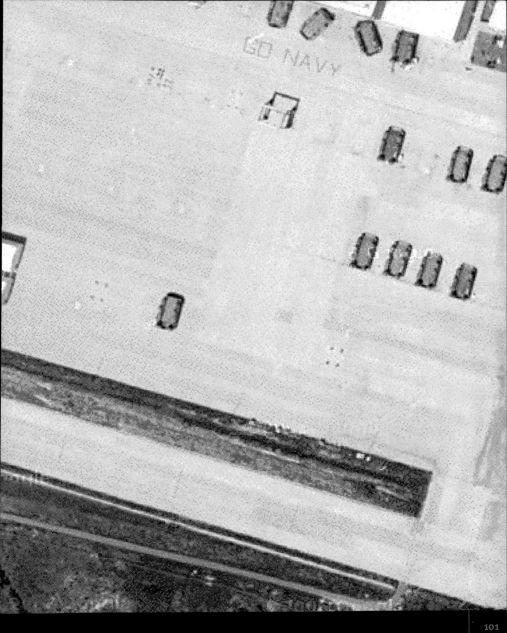

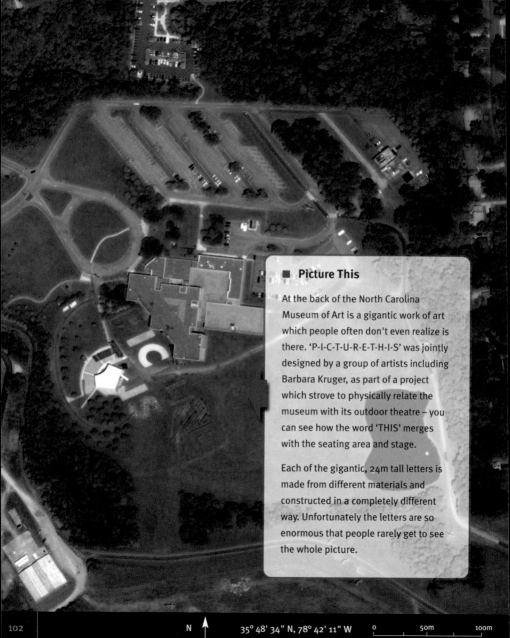

■ Picture This

At the back of the North Carolina Museum of Art is a gigantic work of art which people often don't even realize is there. 'P-I-C-T-U-R-E-T-H-I-S' was jointly designed by a group of artists including Barbara Kruger, as part of a project which strove to physically relate the museum with its outdoor theatre – you can see how the word 'THIS' merges with the seating area and stage.

Each of the gigantic, 24m tall letters is made from different materials and constructed in a completely different way. Unfortunately the letters are so enormous that people rarely get to see the whole picture.

N

35° 48' 34" N, 78° 42' 11" W

0 50m 100m

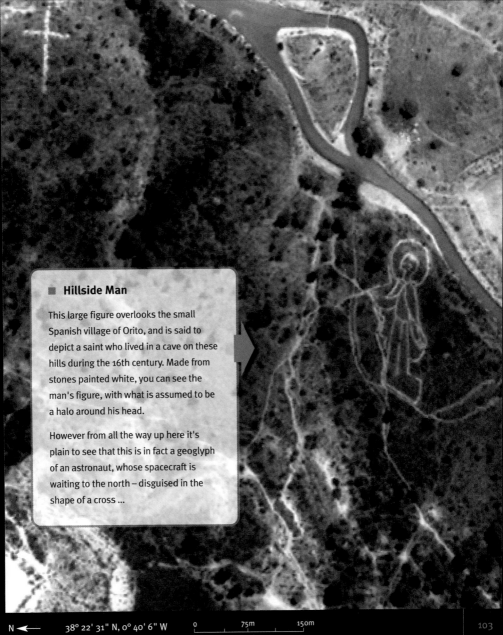

Hillside Man

This large figure overlooks the small Spanish village of Orito, and is said to depict a saint who lived in a cave on these hills during the 16th century. Made from stones painted white, you can see the man's figure, with what is assumed to be a halo around his head.

However from all the way up here it's plain to see that this is in fact a geoglyph of an astronaut, whose spacecraft is waiting to the north – disguised in the shape of a cross ...

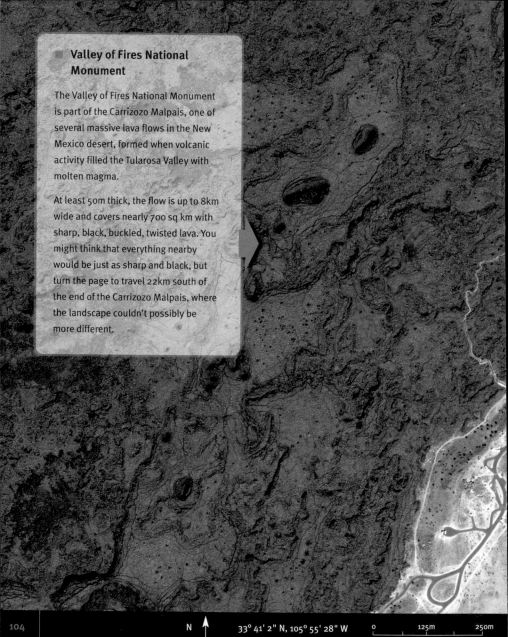

Valley of Fires National Monument

The Valley of Fires National Monument is part of the Carrizozo Malpais, one of several massive lava flows in the New Mexico desert, formed when volcanic activity filled the Tularosa Valley with molten magma.

At least 50m thick, the flow is up to 8km wide and covers nearly 700 sq km with sharp, black, buckled, twisted lava. You might think that everything nearby would be just as sharp and black, but turn the page to travel 22km south of the end of the Carrizozo Malpais, where the landscape couldn't possibly be more different.

N ↑ 33° 41' 2" N, 105° 55' 28" W 0 125m 250m

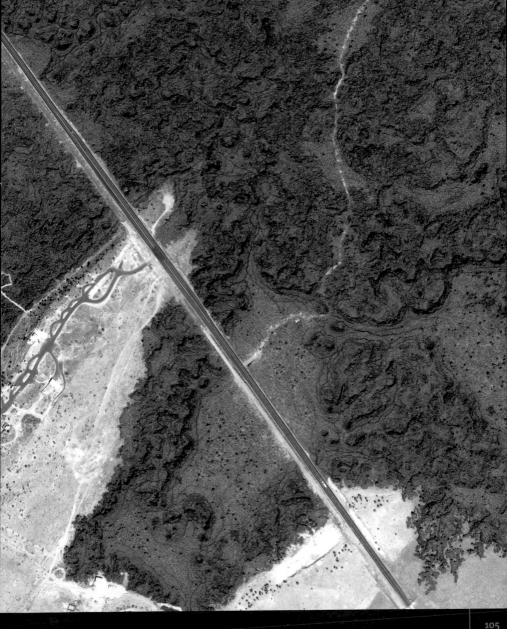

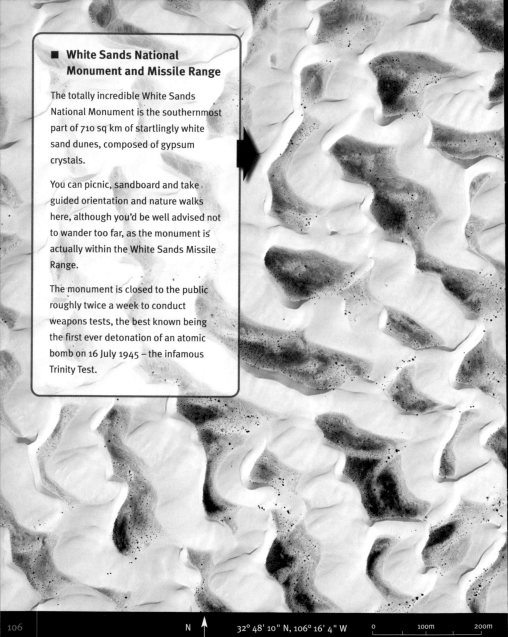

■ White Sands National Monument and Missile Range

The totally incredible White Sands National Monument is the southernmost part of 710 sq km of startlingly white sand dunes, composed of gypsum crystals.

You can picnic, sandboard and take guided orientation and nature walks here, although you'd be well advised not to wander too far, as the monument is actually within the White Sands Missile Range.

The monument is closed to the public roughly twice a week to conduct weapons tests, the best known being the first ever detonation of an atomic bomb on 16 July 1945 – the infamous Trinity Test.

N

32° 48' 10" N, 106° 16' 4" W

0 100m 200m

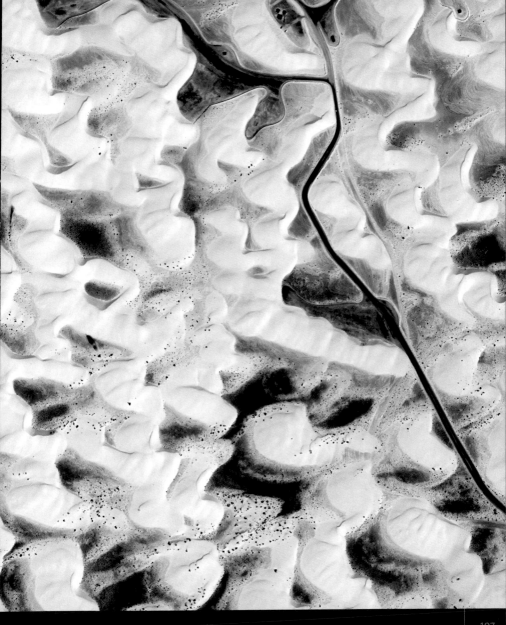

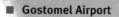

■ Gostomel Airport

Parked at Gostomel Airport north-west of Kiev, Ukraine, we find the only completed Antonov An-225 Mriya (meaning 'Dream'), the world's largest aircraft.

The Mriya weighs 600 tonnes and is 18m high, with a wingspan of 89m and an overall length of 84m. It is now available commercially if you happen to need 200 tonnes of cargo (5 tanks, 8 buses, the fuselage of a Boeing 737 or 1,500 people) flown around the world.

Alternatively, the six-engined, 32-wheel giant can carry up to 250 tonnes externally on the 'roof-rack', originally designed to carry the Buran space shuttle as part of the Soviet Space Program.

N

50° 35' 19" N, 30° 12' 31" E

0 50m 100m

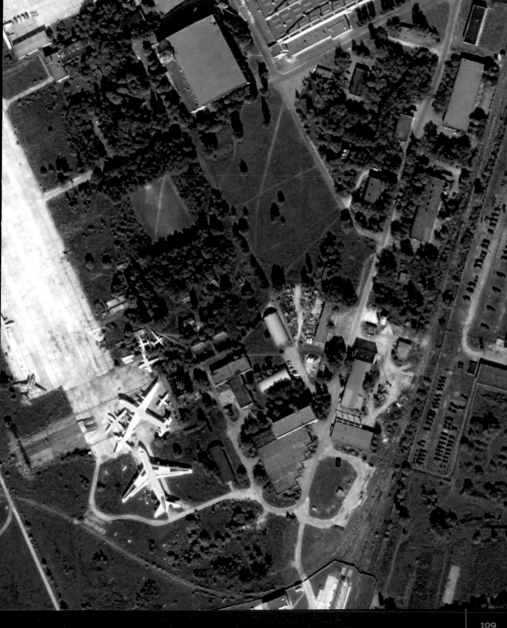

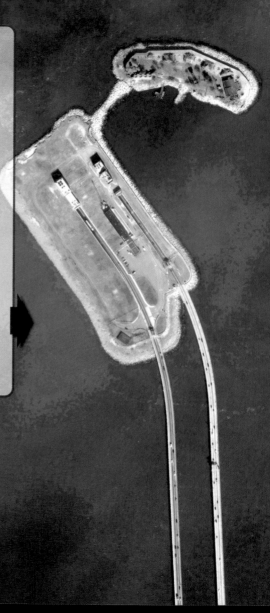

■ The Hampton Roads Bridge-Tunnel

This is the southern end of Hampton Roads Bridge-Tunnel in Virginia, USA. Yes that's right, a bridge-tunnel. It's a bridge, or rather two bridges, which become a tunnel. Two tunnels. Which then become two more bridges. So it has two pairs of bridges and two tunnels.

Still keeping up?

Basically, this is a four-lane facility which incorporates four bridges, two tunnels, trestles, man-made islands and nearly 100,000 vehicles a day.

Why? The facility was designed so that if it were destroyed in wartime, it wouldn't impede the passage of ships from the nearby naval base where the bulk of the

N

36° 58' 53" N, 76° 18' 41" W

0 100m 200m

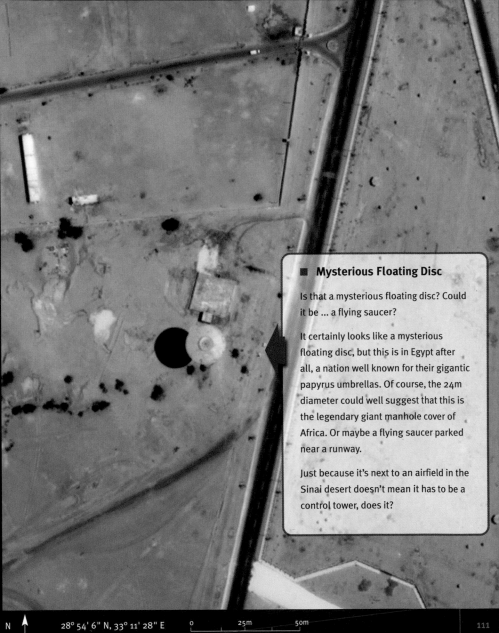

■ Mysterious Floating Disc

Is that a mysterious floating disc? Could it be ... a flying saucer?

It certainly looks like a mysterious floating disc, but this is in Egypt after all, a nation well known for their gigantic papyrus umbrellas. Of course, the 24m diameter could well suggest that this is the legendary giant manhole cover of Africa. Or maybe a flying saucer parked near a runway.

Just because it's next to an airfield in the Sinai desert doesn't mean it has to be a control tower, does it?

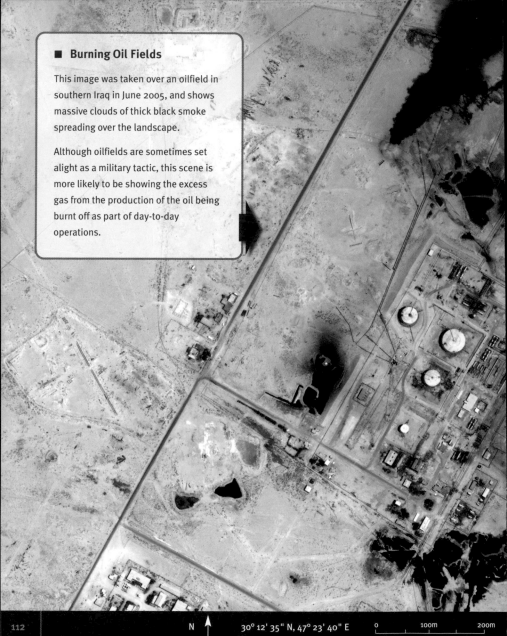

■ Burning Oil Fields

This image was taken over an oilfield in southern Iraq in June 2005, and shows massive clouds of thick black smoke spreading over the landscape.

Although oilfields are sometimes set alight as a military tactic, this scene is more likely to be showing the excess gas from the production of the oil being burnt off as part of day-to-day operations.

N

30° 12' 35" N, 47° 23' 40" E

0 100m 200m

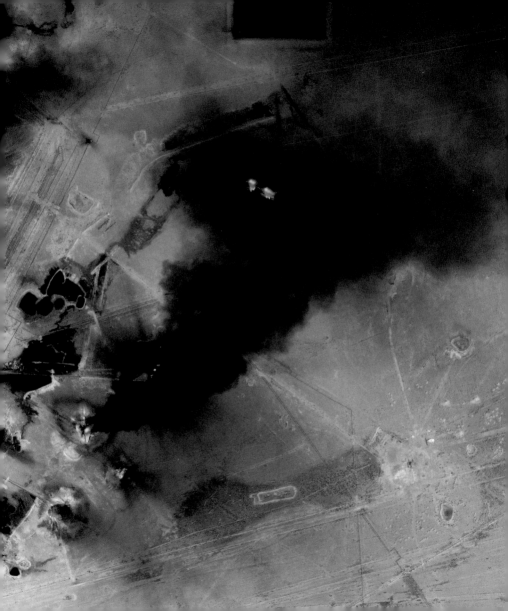

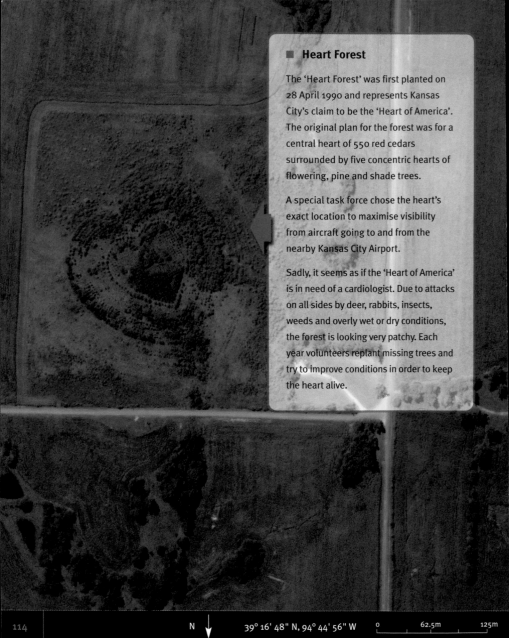

■ Heart Forest

The 'Heart Forest' was first planted on 28 April 1990 and represents Kansas City's claim to be the 'Heart of America'. The original plan for the forest was for a central heart of 550 red cedars surrounded by five concentric hearts of flowering, pine and shade trees.

A special task force chose the heart's exact location to maximise visibility from aircraft going to and from the nearby Kansas City Airport.

Sadly, it seems as if the 'Heart of America' is in need of a cardiologist. Due to attacks on all sides by deer, rabbits, insects, weeds and overly wet or dry conditions, the forest is looking very patchy. Each year volunteers replant missing trees and try to improve conditions in order to keep the heart alive.

N

39° 16' 48" N, 94° 44' 56" W

0 62.5m 125m

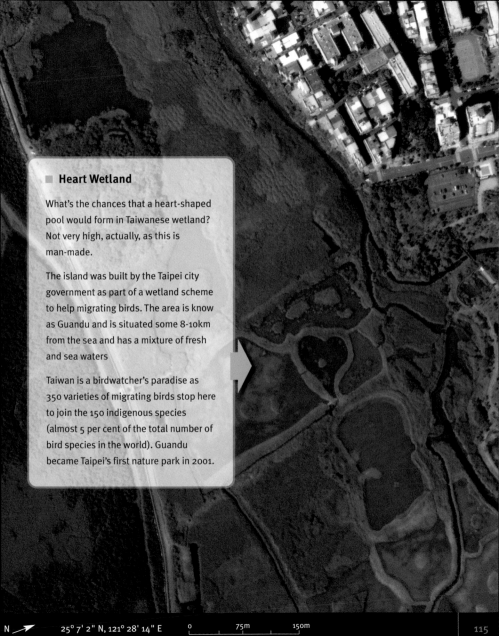

Heart Wetland

What's the chances that a heart-shaped pool would form in Taiwanese wetland? Not very high, actually, as this is man-made.

The island was built by the Taipei city government as part of a wetland scheme to help migrating birds. The area is know as Guandu and is situated some 8-10km from the sea and has a mixture of fresh and sea waters

Taiwan is a birdwatcher's paradise as 350 varieties of migrating birds stop here to join the 150 indigenous species (almost 5 per cent of the total number of bird species in the world). Guandu became Taipei's first nature park in 2001.

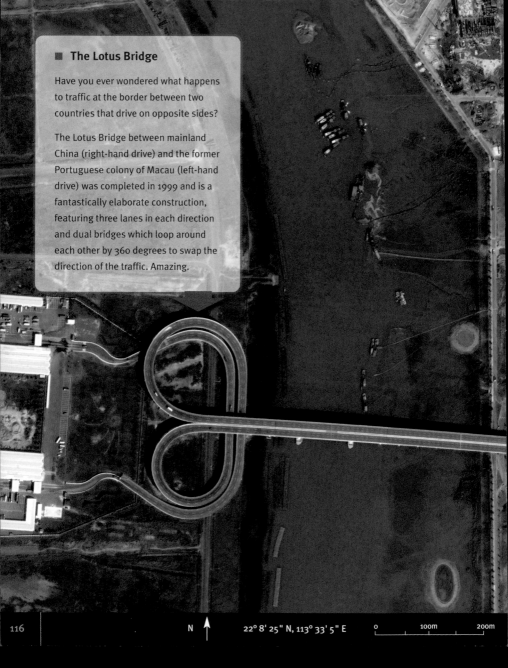

■ The Lotus Bridge

Have you ever wondered what happens to traffic at the border between two countries that drive on opposite sides?

The Lotus Bridge between mainland China (right-hand drive) and the former Portuguese colony of Macau (left-hand drive) was completed in 1999 and is a fantastically elaborate construction, featuring three lanes in each direction and dual bridges which loop around each other by 360 degrees to swap the direction of the traffic. Amazing.

N ↑ 22° 8' 25" N, 113° 33' 5" E 0 100m 200m

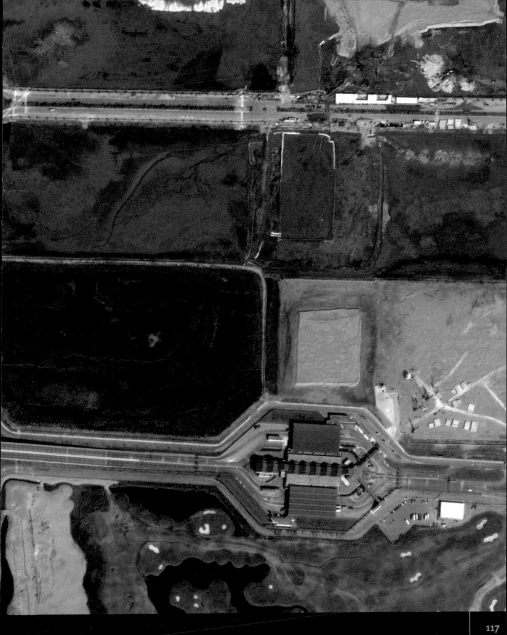

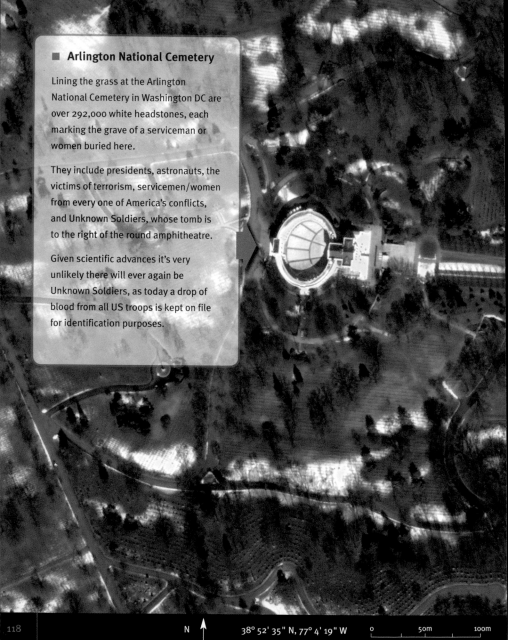

■ Arlington National Cemetery

Lining the grass at the Arlington National Cemetery in Washington DC are over 292,000 white headstones, each marking the grave of a serviceman or women buried here.

They include presidents, astronauts, the victims of terrorism, servicemen/women from every one of America's conflicts, and Unknown Soldiers, whose tomb is to the right of the round amphitheatre.

Given scientific advances it's very unlikely there will ever again be Unknown Soldiers, as today a drop of blood from all US troops is kept on file for identification purposes.

N

38° 52' 35" N, 77° 4' 19" W

0 50m 100m

Wat Phra That Doi Suthep

Overlooking the city of Chiang Mai in northern Thailand from its mountain-top location 1073m above sea level, is the ancient temple of Wat Phra That Doi Suthep. The temple is reached via a giant 290-step staircase, which is lined on both sides by the elongated body of a seven-headed naga (snake demon).

The inconvenient location for the temple was apparently chosen by a white elephant carrying one of the Lord Buddha's bones and it was once rumoured that due to its elevation and strategic location the temple housed a CIA transmission device.

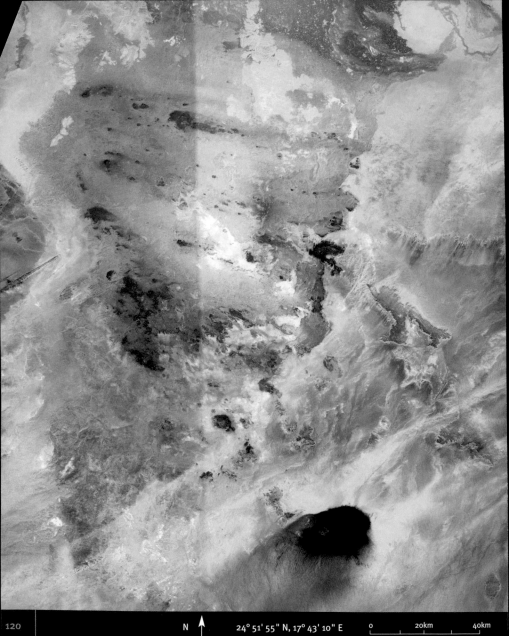

N 24° 51' 55" N, 17° 43' 10" E 0 20km 40km

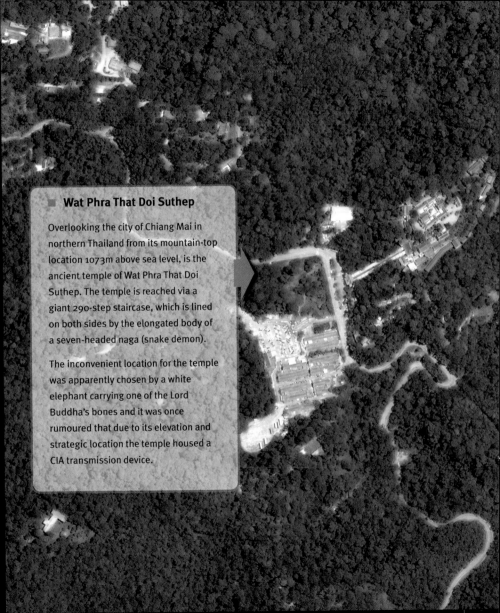

Wat Phra That Doi Suthep

Overlooking the city of Chiang Mai in
northern Thailand from its mountain-top
location 1073m above sea level, is the
ancient temple of Wat Phra That Doi
Suthep. The temple is reached via a
giant 290-step staircase, which is lined
on both sides by the elongated body of
a seven-headed naga (snake demon).

The inconvenient location for the temple
was apparently chosen by a white
elephant carrying one of the Lord
Buddha's bones and it was once
rumoured that due to its elevation and
strategic location the temple housed a
CIA transmission device.

N

18° 48' 16" N, 98° 55' 16" E

0 100m 200m

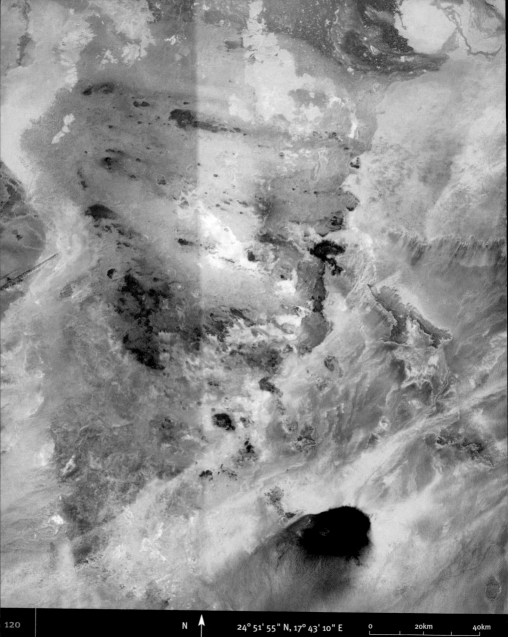

N 24° 51' 55" N, 17° 43' 10" E

0 20km 40km

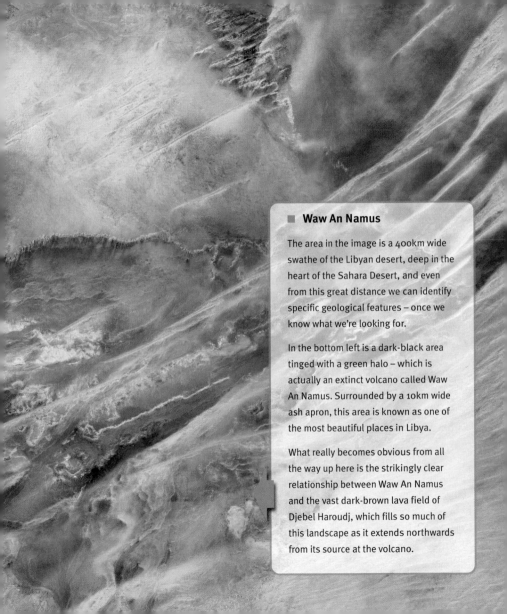

Waw An Namus

The area in the image is a 400km wide swathe of the Libyan desert, deep in the heart of the Sahara Desert, and even from this great distance we can identify specific geological features – once we know what we're looking for.

In the bottom left is a dark-black area tinged with a green halo – which is actually an extinct volcano called Waw An Namus. Surrounded by a 10km wide ash apron, this area is known as one of the most beautiful places in Libya.

What really becomes obvious from all the way up here is the strikingly clear relationship between Waw An Namus and the vast dark-brown lava field of Djebel Haroudj, which fills so much of this landscape as it extends northwards from its source at the volcano.

■ Banderas Monumentales

In the late 1990s the President of Mexico began a state sponsored program of erecting 'Banderas monumentales' ('monumental flags') at various locations around Mexico that had played an important part in the country's history – three of which happened to be on the border with the USA, like this one at the international bridge between Laredo, Texas and Nuevo Laredo, Mexico.

In the official decree it was stated the the flags should be 14.3m by 25m in size, but for the Laredo border they upped the ante and erected a massive flag 28.6m x 50m (that's half a football field), hoisted up on a 103m flagpole (that's the length of a football field).

For some Americans the sight of a Mexican flag towering over the area offended them, so just across the border the Laredo National Bank splashed out $300,000 on a 94m flagpole with a 15m x 30m flag.

N

27° 29' 52" N, 99° 30' 16" W

0 50m 100m

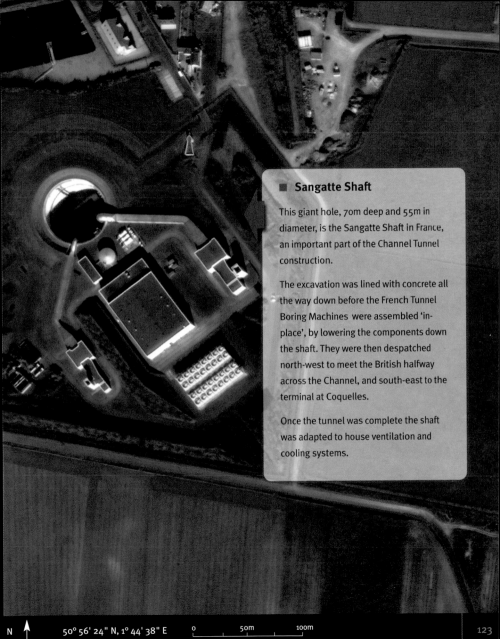

Sangatte Shaft

This giant hole, 70m deep and 55m in diameter, is the Sangatte Shaft in France, an important part of the Channel Tunnel construction.

The excavation was lined with concrete all the way down before the French Tunnel Boring Machines were assembled 'in-place', by lowering the components down the shaft. They were then despatched north-west to meet the British halfway across the Channel, and south-east to the terminal at Coquelles.

Once the tunnel was complete the shaft was adapted to house ventilation and cooling systems.

N

50° 56' 24" N, 1° 44' 38" E

0 50m 100m

N

33° 18' 26" N, 44° 23' 11" E

0 100m 200m

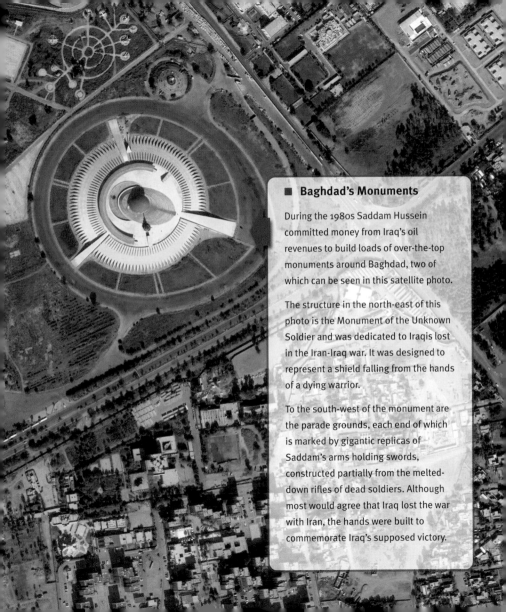

Baghdad's Monuments

During the 1980s Saddam Hussein committed money from Iraq's oil revenues to build loads of over-the-top monuments around Baghdad, two of which can be seen in this satellite photo.

The structure in the north-east of this photo is the Monument of the Unknown Soldier and was dedicated to Iraqis lost in the Iran-Iraq war. It was designed to represent a shield falling from the hands of a dying warrior.

To the south-west of the monument are the parade grounds, each end of which is marked by gigantic replicas of Saddam's arms holding swords, constructed partially from the melted-down rifles of dead soldiers. Although most would agree that Iraq lost the war with Iran, the hands were built to commemorate Iraq's supposed victory.

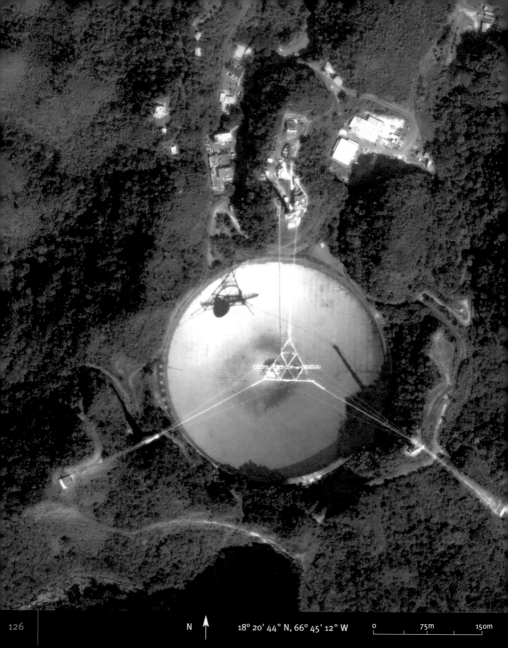

N

18° 20' 44" N, 66° 45' 12" W

0 75m 150m

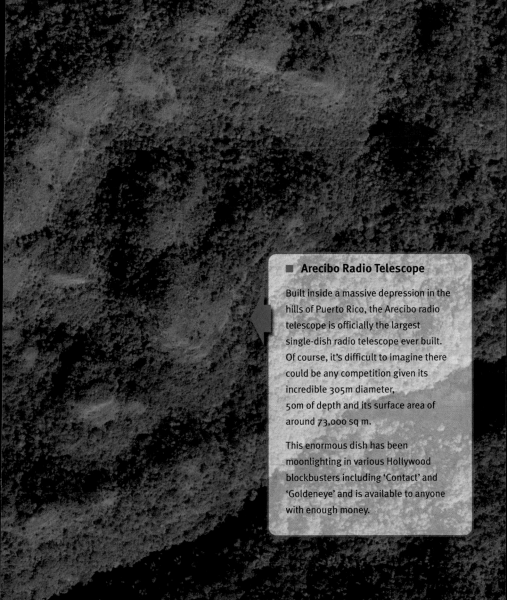

■ Arecibo Radio Telescope

Built inside a massive depression in the hills of Puerto Rico, the Arecibo radio telescope is officially the largest single-dish radio telescope ever built. Of course, it's difficult to imagine there could be any competition given its incredible 305m diameter, 50m of depth and its surface area of around 73,000 sq m.

This enormous dish has been moonlighting in various Hollywood blockbusters including 'Contact' and 'Goldeneye' and is available to anyone with enough money.

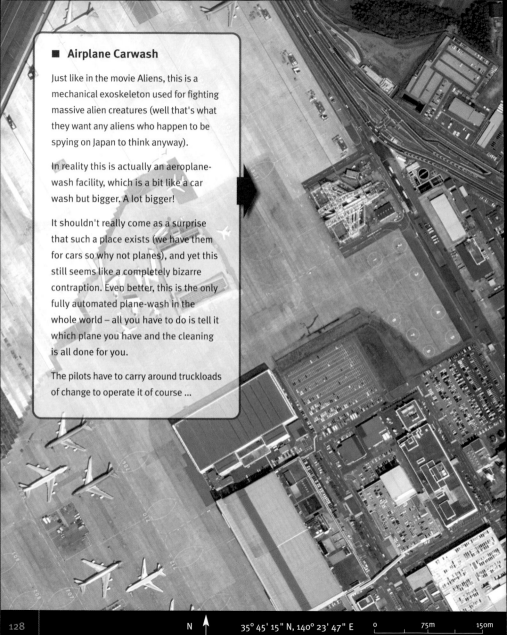

■ Airplane Carwash

Just like in the movie Aliens, this is a mechanical exoskeleton used for fighting massive alien creatures (well that's what they want any aliens who happen to be spying on Japan to think anyway).

In reality this is actually an aeroplane-wash facility, which is a bit like a car wash but bigger. A lot bigger!

It shouldn't really come as a surprise that such a place exists (we have them for cars so why not planes), and yet this still seems like a completely bizarre contraption. Even better, this is the only fully automated plane-wash in the whole world – all you have to do is tell it which plane you have and the cleaning is all done for you.

The pilots have to carry around truckloads of change to operate it of course …

N

35° 45' 15" N, 140° 23' 47" E

0 75m 150m

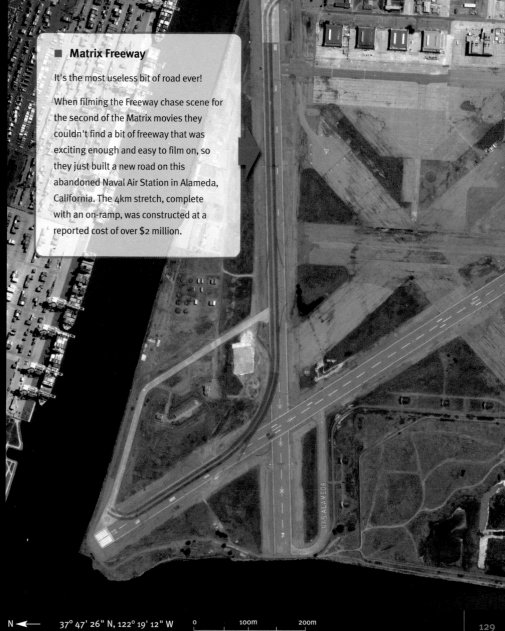

Matrix Freeway

It's the most useless bit of road ever!

When filming the Freeway chase scene for the second of the Matrix movies they couldn't find a bit of freeway that was exciting enough and easy to film on, so they just built a new road on this abandoned Naval Air Station in Alameda, California. The 4km stretch, complete with an on-ramp, was constructed at a reported cost of over $2 million.

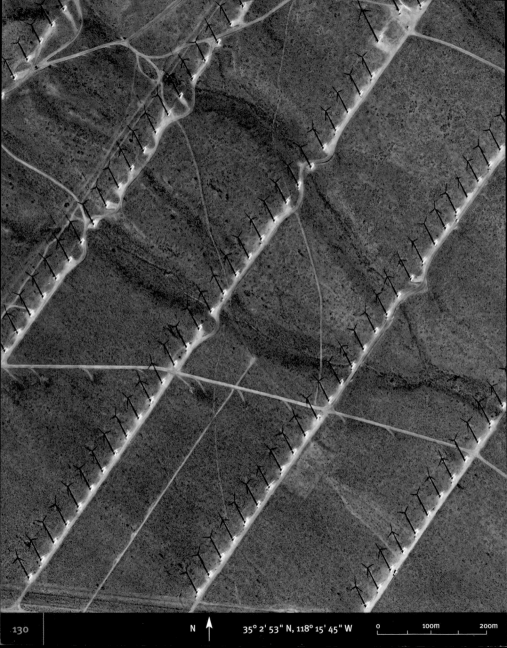

N

35° 2' 53" N, 118° 15' 45" W

0 100m 200m

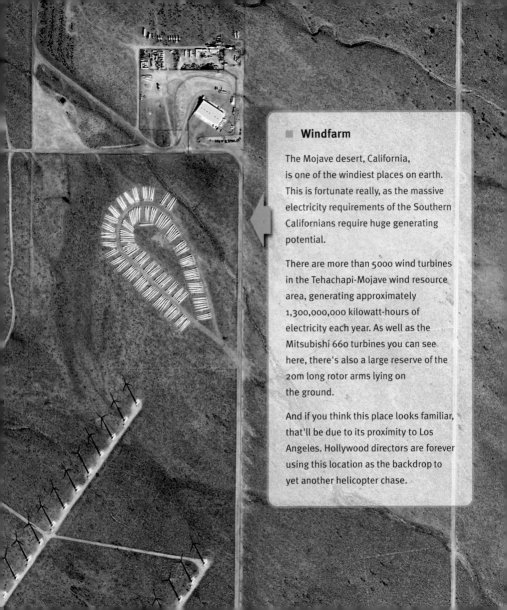

Windfarm

The Mojave desert, California, is one of the windiest places on earth. This is fortunate really, as the massive electricity requirements of the Southern Californians require huge generating potential.

There are more than 5000 wind turbines in the Tehachapi-Mojave wind resource area, generating approximately 1,300,000,000 kilowatt-hours of electricity each year. As well as the Mitsubishi 660 turbines you can see here, there's also a large reserve of the 20m long rotor arms lying on the ground.

And if you think this place looks familiar, that'll be due to its proximity to Los Angeles. Hollywood directors are forever using this location as the backdrop to yet another helicopter chase.

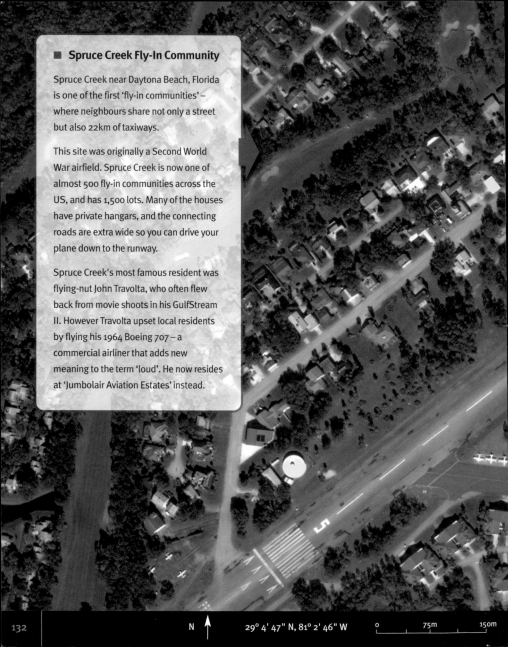

■ Spruce Creek Fly-In Community

Spruce Creek near Daytona Beach, Florida is one of the first 'fly-in communities' – where neighbours share not only a street but also 22km of taxiways.

This site was originally a Second World War airfield. Spruce Creek is now one of almost 500 fly-in communities across the US, and has 1,500 lots. Many of the houses have private hangars, and the connecting roads are extra wide so you can drive your plane down to the runway.

Spruce Creek's most famous resident was flying-nut John Travolta, who often flew back from movie shoots in his GulfStream II. However Travolta upset local residents by flying his 1964 Boeing 707 – a commercial airliner that adds new meaning to the term 'loud'. He now resides at 'Jumbolair Aviation Estates' instead.

N ↑

29° 4' 47" N, 81° 2' 46" W

0 75m 150m

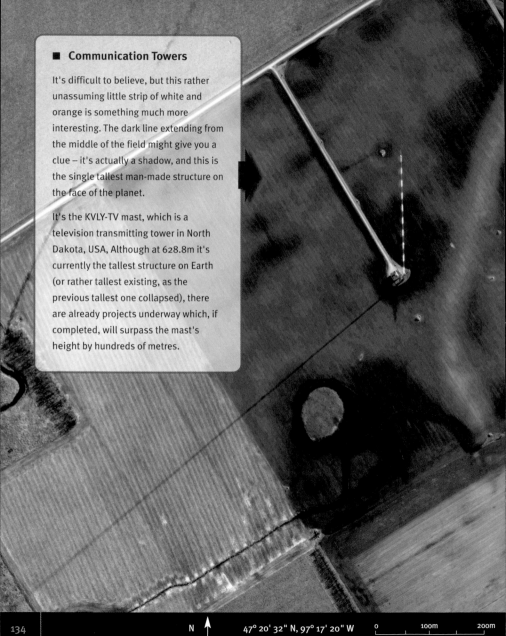

■ Communication Towers

It's difficult to believe, but this rather unassuming little strip of white and orange is something much more interesting. The dark line extending from the middle of the field might give you a clue – it's actually a shadow, and this is the single tallest man-made structure on the face of the planet.

It's the KVLY-TV mast, which is a television transmitting tower in North Dakota, USA, Although at 628.8m it's currently the tallest structure on Earth (or rather tallest existing, as the previous tallest one collapsed), there are already projects underway which, if completed, will surpass the mast's height by hundreds of metres.

N

47° 20' 32" N, 97° 17' 20" W

0 100m 200m

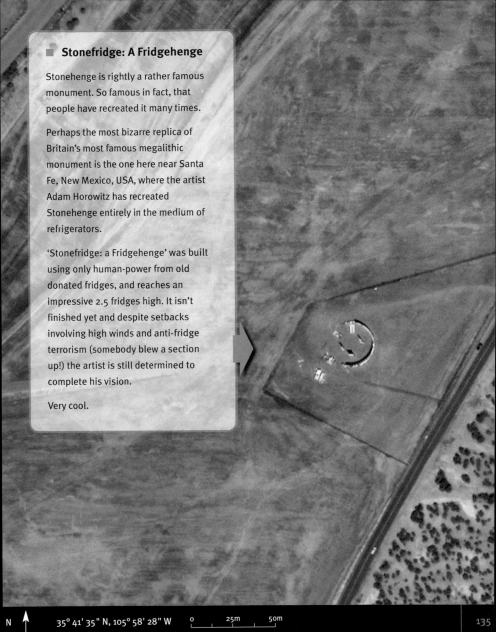

Stonefridge: A Fridgehenge

Stonehenge is rightly a rather famous monument. So famous in fact, that people have recreated it many times.

Perhaps the most bizarre replica of Britain's most famous megalithic monument is the one here near Santa Fe, New Mexico, USA, where the artist Adam Horowitz has recreated Stonehenge entirely in the medium of refrigerators.

'Stonefridge: a Fridgehenge' was built using only human-power from old donated fridges, and reaches an impressive 2.5 fridges high. It isn't finished yet and despite setbacks involving high winds and anti-fridge terrorism (somebody blew a section up!) the artist is still determined to complete his vision.

Very cool.

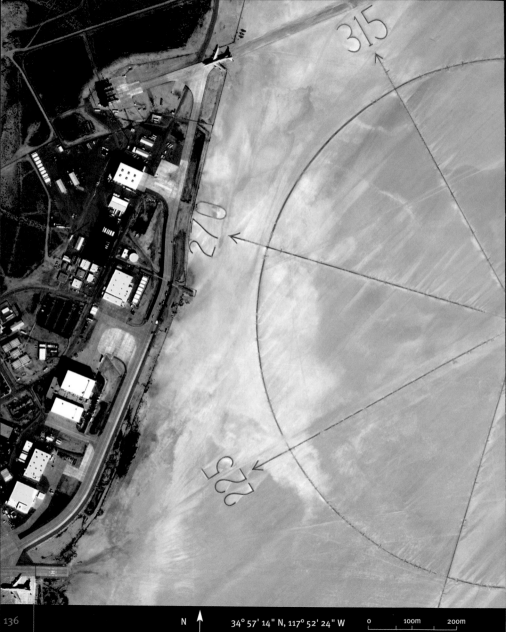

315

270

225

N ↑ 34° 57' 14" N, 117° 52' 24" W 0 100m 200m

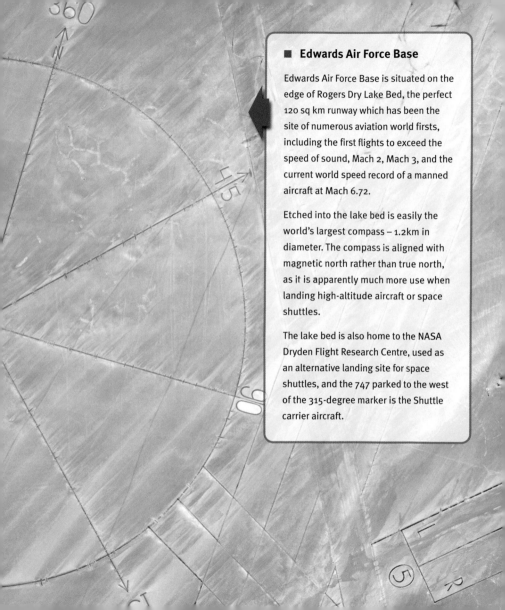

Edwards Air Force Base

Edwards Air Force Base is situated on the edge of Rogers Dry Lake Bed, the perfect 120 sq km runway which has been the site of numerous aviation world firsts, including the first flights to exceed the speed of sound, Mach 2, Mach 3, and the current world speed record of a manned aircraft at Mach 6.72.

Etched into the lake bed is easily the world's largest compass – 1.2km in diameter. The compass is aligned with magnetic north rather than true north, as it is apparently much more use when landing high-altitude aircraft or space shuttles.

The lake bed is also home to the NASA Dryden Flight Research Centre, used as an alternative landing site for space shuttles, and the 747 parked to the west of the 315-degree marker is the Shuttle carrier aircraft.

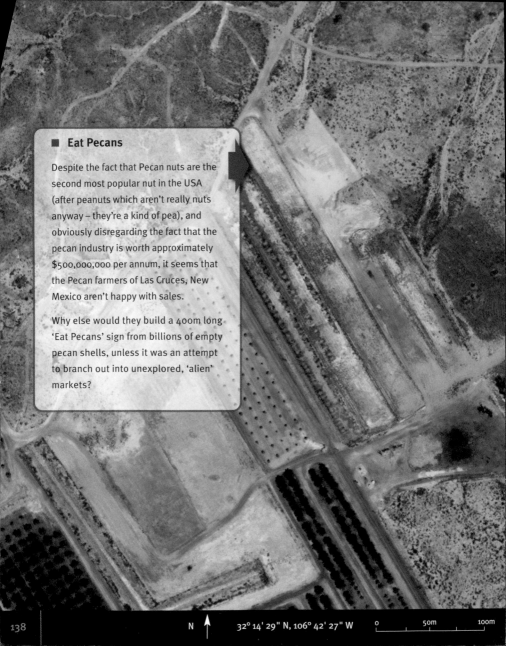

■ **Eat Pecans**

Despite the fact that Pecan nuts are the second most popular nut in the USA (after peanuts which aren't really nuts anyway – they're a kind of pea), and obviously disregarding the fact that the pecan industry is worth approximately $500,000,000 per annum, it seems that the Pecan farmers of Las Cruces, New Mexico aren't happy with sales.

Why else would they build a 400m long 'Eat Pecans' sign from billions of empty pecan shells, unless it was an attempt to branch out into unexplored, 'alien' markets?

N ↑ 32° 14' 29" N, 106° 42' 27" W 0 50m 100m

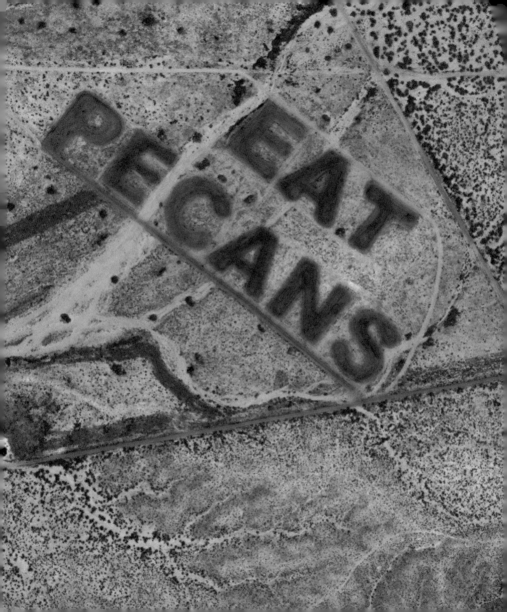

Chaco Canyon

Chaco Culture National Historical Park in New Mexico was the heart of the ancestral Puebloan culture between AD 850 and 1250. In this section of the canyon is 'Pueblo Bonita', the largest of the monumental 'great houses' the people built, which at one time would have had more than 600 rooms and towered 4 or 5 storeys high.

Unfortunately the popularity of Chaco Canyon as a tourist destination has led to fears of erosion of these culturally and historically important sites. Already one location in the park has been closed completely to the public, and eventually Pueblo Bonita and all the other great houses could be closed too.

N ← 36° 3' 37" N, 107° 57' 41" W

0 25m 50m

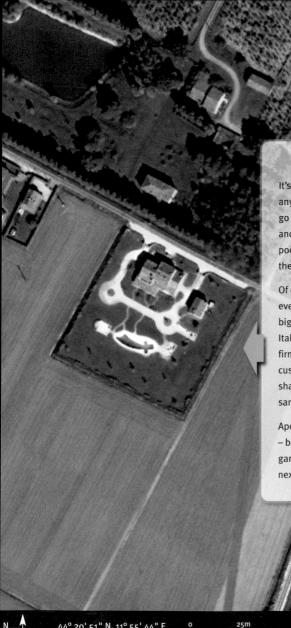

Scimitar Pool

It's a scientific fact that the first thing anybody does with satellite imagery is go looking for their own house and try and see their car, garden, swimming pool or anything else recognisable in their neighbourhood.

Of course, we couldn't feature everybody's house (it would be a very big book) so we've opted for just one: an Italian butcher. Apparently his butchery firm is doing rather well and he's had his custom swimming pool built in the shape of a scimitar sword, which is the same image as his company's logo.

Apologies to everyone else in the globe – build something interesting in your garden and we may feature your house next time!

■ About the Images in This Book

Most of the images in this book were captured by the QuickBird satellite between 2003 and 2006 at a resolution of 60cm per pixel, and supplied by DigitalGlobe. The less detailed entries (pages 10, 19. 32, 36, 82, 96, and 120) are 15m per pixel satellite images taken by NASA's Landsat 7 satellite, were collected between 1999 and 2002, and supplied by TerraMetrics.

For each entry we've listed the latitude and longitude so you can browse the area in Google Earth on your own Mac or PC, or you can load up all the entries featured in this book by visiting www.notintheguidebook.com/kml

Finally, yes, every single image in this book was taken by a satellite (well, except the one of us that is).